STEP-BY-STEP • AWESOME ART & ARTIST

HOW TO DR...

MANGA

MADE EASY

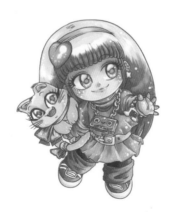

Publisher and Creative Director: Nick Wells

Project Editor: Laura Bulbeck

Picture Research: Helen McCarthy

Art Director: Mike Spender

Digital Design and Production: Chris Herbert

Special thanks to the artists who contributed their fantastic work to this book.

Dedication: For Marc, Becky and Beto – art lovers all.

FLAME TREE PUBLISHING

Crabtree Hall, Crabtree Lane

Fulham, London SW6 6TY

United Kingdom

www.flametreepublishing.com

First published 2015

15 17 19 18 16

1 3 5 7 9 10 8 6 4 2

A CIP record for this book is available from the British Library upon request.

Images used in this book are © the artists as stated except:
page 8: © SonyStudios/Photoshot.

ISBN: 978-1-78361-592-6

Printed in China

STEP-BY-STEP • AWESOME ART & ARTISTS

HOW TO DRAW
MANGA
MADE EASY

FOREWORD BY
RIKKI SIMONS

GENERAL EDITOR:
HELEN McCARTHY

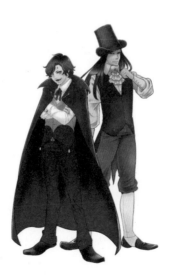

FLAME TREE
PUBLISHING

CONTENTS

To help you understand manga better before you get started, this chapter gives a short history of manga, a few facts about its importance in Japanese culture, and some pointers about developing basic art skills.

Getting started with the help of our top team of artist/tutors.

DRAWING SKILLS 20

In this chapter you'll learn some of the basic skills such as drawing faces and figures, and using both manual and digital tools. It explores creating expressive faces and figure proportions, how to make magic with markers and more.

PAGE LAYOUT 56

In this chapter you'll see how two different artists lay out their pages to tell stories in their own way. One is American, one British – one is an experienced professional and one a self-taught, self-published new talent.

PAGEMAKING STEP BY STEP 74

In this chapter you'll see more examples of artists laying out pages to move their story along. As you'll see, the panel layouts, number of characters in a panel, amount of background detail and the position of lettering all change the mood and pace of the action.

THE ART OF CUTE 104

In this chapter we explore cuteness - or kawaii as it's known in Japan. Cuteness can be a girl dressed in ornate Lolita fashion, or a small child or animal. It can be funny, charming, melancholy or romantic.

HEAVY METAL 134

In this chapter we look at mecha, a term used to describe all things mechanical. We tend to think of mecha as robots, tanks and other armoured vehicles – but mecha can be literally anything mechanical, from household implements to mundane cars and tractors.

CREATING A CREDIBLE WORLD 166

In this chapter we explore how artists make characters more convincing through the right costume and setting. As a creator it's your job to make sure the look of your world – the clothing, buildings, settings and details – works to support your characters and story.

SELLING WITH MANGA STYLE 202

In this chapter learn how to create an image with real selling power. A cover needs as much care and consideration as the story – it's a major part of its saleability. Even if you're publishing online for free, a great cover or poster image is vital.

FOREWORD

MANGA AND THE LEGACY OF OSAMU TEZUKA

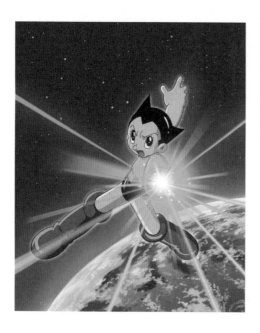

In 1979 when Tavisha Wolfgarth-Simons (whose art you can see in this very book) was 13 she went to see a special screening of Osamu Tezuka's (*Astro Boy*, *Kimba the White Lion*) Phoenix 2772 anime at the University of California, Los Angeles (UCLA).

To her surprise Tezuka Sensei himself, the father of manga, made an appearance at the screening and while she stood in the queue to meet him, she hastily scribbled a collection of original 'manga-style' characters to show him. He critiqued them with a smile, telling her, 'These are very good but I would make the eyes smaller, because the trend now is to make the eyes less large.'

And that is the thing about manga and anime: it is an art movement, always changing, it is fashion and trend, high art and commercial graphics, it is every genre and politic under an aesthetic that flows with the rise and fall of the progress of time as if it were lungs adjusting themselves as they taste air in different altitudes and climates.

In truth, there is really no one style that can be nailed down as manga because it is more than a mere pastiche, greater than a reproduction of the same ideas. Within the familiar trend-making of big or small eyes, speed lines, or pregnant pauses between comic panels, there is an exhale of commentary and deconstruction for every inhalation of concepts that came before. This is central to the meaning of art. Good artists can use any familiar aesthetic to express something new.

Those of us who have been influenced by manga and anime creators such as Osamu Tezuka or Hayao Miyazaki (*Nausicaä of the Valley of the Wind*, *Spirited Away*) can be seen as the echo of the art form. It is an echo that is sure to reverberate for decades to come, and the universal forms and shapes in which it will take may lead back to the beginning, when Tezuka himself was first influenced by comics from outside Japan. Regardless, in the end and in our minds, we're all still young artists excited by an evolving art movement, queuing up to show our creations to each other, scribbling shapes with personal meaning.

Rikki Simons
Voice actor, writer, and artist

MANGA: WHAT, WHY, HOW

This book is here to help you develop or improve your manga art skills. Whether you've never picked up a pencil to draw outside art lessons at school, or you're an experienced artist looking for new tips and tricks; whether you love making art on the computer or prefer to use non-digital methods, these pages packed with artist tutorials have something for you.

THREE THINGS TO REMEMBER

The three most important things to remember about manga are:

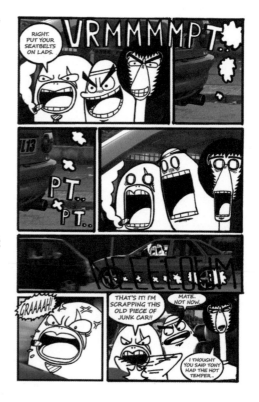

- It's the Japanese word for **comic**. To the Japanese, Iron Man and Superman are manga. So manga art is Japan's own form of comic art.

- There is no single '**manga style**'. Anyone who reads manga will soon notice that there are a huge range of **different art styles**, from the realistic to the downright grotesque.

- Every artist who makes manga makes it in his or her own way. Your **personal style** and **creativity** is the most important thing to bring to your manga.

THE HISTORY OF MANGA

Manga is deeply embedded in Japanese history. The word itself has been around since the late 1700s. But manga in the modern sense didn't really develop until Japan re-opened her borders to the world after 250 years of isolation. The Japanese middle classes had money to spend and were hungry for novelty. They eagerly embraced the exotic West and all its imports, including Western art.

A young Londoner named Charles Wirgman came over from China as a reporter for the *Illustrated London News* and started up a business teaching Western painting and Western cartooning. He also founded a magazine for expatriates, the *Japan Punch*, where his satirical sketches making fun of the top people in society impressed young Japanese artists to try the same thing. Soon cartoon magazines began to spread in Japan, and before the *Japan Punch* closed after almost 25 years of successful sales across Asia the manga movement was unstoppable.

Effects of War

During Japan's period of military aggression in the first half of the twentieth century, and especially after her entry into the Second World War after Pearl Harbour, manga was a propaganda tool. Artists who would not toe the military line were unable to get paper or find work, and anyone considered to be a critic of Japan's role in Asia and in the war was likely to be sent to the front lines, where the vast majority of soldiers died.

In the immediate aftermath of war, with poverty and starvation common in Japan, manga were one of the few cheap and easily accessible forms of entertainment. Children could buy them for a few pennies, and those without a penny could find them in the rubbish. Keiji

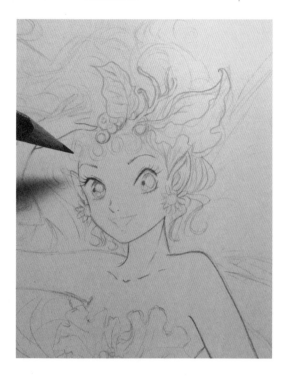

Nakazawa found a discarded comic while scavenging for food among the ruins of his hometown and was inspired to become a manga artist when he grew up.

Osamu Tezuka

That comic was *Shintakarajima* – New Treasure Island – by the teenage prodigy Osamu Tezuka. Tezuka was a hugely influential figure in manga from his debut in 1946. Even though he died in 1989 he is still a powerful influence in the manga world. His work inspired generations of young artists. Because he was too young to serve in the armed forces, and lucky enough to survive the Allied bombing, he was able to form a bridge between the comics he loved as a child in the 1930s and the comics he wanted to make for postwar Japan.

Tezuka was also a huge fan of films and animation from Europe and America, and brought some of the styles he saw onscreen to the comic page. His work for children was informed by his love for the cartoons of Walt Disney and the Fleischer Brothers, giving his figures a soft, rounded line with the huge, wide eyes that Westerners now consider one of the trademarks of manga art. In his adult work he used a combination of realism and the distortion and grotesquerie he found in art-house movies. The incredibly popular *Astro Boy*, one of the earliest Japanese anime, started life as a manga both written and illustrated by Tezuka.

The artists working alongside him and those who followed adopted a wide range of styles and created the right environment for the diverse, exciting manga of today.

MANGA FORMATS

Manga appear in four major formats:

Manga Magazine

The first and most familiar in Japan is the manga magazine. These are books as thick as telephone directories, often about eight by ten inches in size, printed on cheap paper with brightly coloured covers. They appear weekly, fortnightly or monthly and contain serialised manga stories from newcomers as well as big names. Each issue has a dozen or more serials.

Tankobon

The second, and most familiar in the West, is the *tankobon*, or collected edition. These are smaller in size, printed on better quality paper, and contain the collected episodes of a single story. Most manga magazines are thrown out with the recycling every week. Tankobon are for fans who want to keep their favourite stories on the bookshelf.

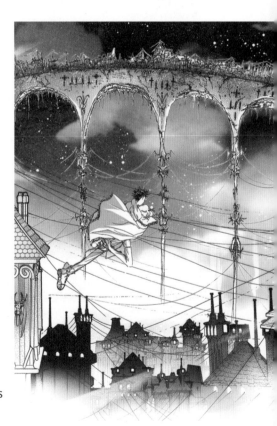

Newspaper Strip

The third format is the newspaper strip. Just as in Europe and America, newspapers in Japan run short cartoon strips in every issue.

Online

The fourth is online. Japan has a huge market for comics ceased for the computer or cellphone.

MANGA AUDIENCES

There are different types of manga for different genders and age groups. *Kodomo* manga are for small children, while girls and boys aged around nine to sixteen are catered for by *shojo* and *shonen* manga respectively. *Seinen* manga are for adult men and *josei* manga for adult women.

Gekiga are what's known in English as graphic novels, aimed at older high school and college age readers. *Yonkoma* are the comic strips you find in newspapers, three or four panels, usually self-contained. *Dojinshi* are fan-created comics. *Hentai* is the term for pornographic manga. You can also find *yuri* (lesbian) and *yaoi* or *shonen ai* (homosexual) manga, which can be straightforward same-sex romance or drama with no pornographic elements.

The biggest selling manga are usually those for the teen and college age male market. *One Piece* by Eiichiro Oda is the biggest selling manga in Japan to date. The former champion, Akira Toriyama's *Dragon Ball*, is number two in the bestseller list.

But the longest running manga are not necessarily on the bestseller list, and many of them have never been published in the West. Sales figures are usually based on collected editions. This excludes long running serials in the weekly and monthly manga magazines, and newspaper strips. Some strips have run for many years in newspapers, read every day by millions of Japanese.

STARTING OUT

Manga is storytelling through drawing. If you find your comic pages are crowded with word balloons, maybe the novel or the short story is your natural medium. The magic of manga is the ability to tell a story through lines and images. That's no disrespect to the written word - it's just a different way of telling the story.

Making Images

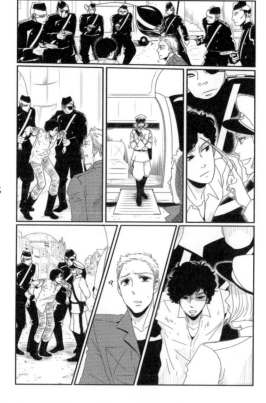

But before you can tell a story through images, you have to make the images. There are a huge number of ways to do this. Two of the artists in this book make their images using photography as a base. Some artists make very extensive use of the screentones you can buy in huge variety in Japan, sometimes for the majority of backgrounds in a story. Some artists use stick figures or deliberately childlike, naive drawings. It's up to you, the artist, to decide how you want to make your work.

Drawing Skills

It's a good idea, though, to develop your drawing skills as far as you can. The greatest masters of distortion in fine art, like Pablo Picasso, Salvador Dali and Francis Bacon, had superb conventional drawing skills. It was that solid foundation that enabled them to push the distortion of form so far. Manga artists like Toshio Maeda and Naoki Urusawa are excellent draughtsmen. There a huge number of books that will help you develop drawing skills – look at the section on Further Reading at the back of this book, or try browsing the art section in your local library.

Draw More

But the best way to get better at drawing is to draw more. Ideally you need to draw every day. Every would-be artist needs a small hardback notebook – around six by eight inches is a good size, but whatever feels right to you, and fits in your bag or pocket easily, is fine. You want to be able to pull it out anywhere, anytime.

It needs to have a hard cover so you have a stable, flat surface to rest on as you doodle. It doesn't have to be a fancy artist's notebook with expensive paper, but if you buy a cheap one with lined pages, make sure the lines are pale blue. This is because the paler tones of blue don't contrast strongly with white paper and so are not easily picked up by a scanner or copier.

Some of the artists in this book use blue pencil for basic sketches. You can draw on top of the blue lines to tidy up and refine your work, using graphite pencil or ink. When you scan the work into a computer, or photocopy it, you'll just get the darker lines of your refined drawing. The blue won't show up. It saves you time on erasing your basic drawing, which can damage the paper you're working on.

COPYING OTHER ARTISTS' WORK

Copying is one of the ways every artist learns new skills from old hands. The great masters of the Renaissance, like Raphael and Michelangelo, copied as a

way to improve their own drawings. Japanese master Hokusai published his sketchbooks under the title *Hokusai Manga*, and artists all over Japan bought copies to study.

If you love the work of CLAMP or if *Naruto* or *Bleach* are the kind of manga you'd love to make, copy to your heart's content. Copying how your favourite artists handle figures, backgrounds, and action scenes will help you to learn how to use the same techniques in your own work.

The only thing you absolutely must not do is to try and pass copies of their work off as your own originals, especially not if you want to sell them. For one thing, it's stealing. For another, unless you really are as good as the person whose work you're ripping off, it's going to be obvious to everyone who looks at your work that you've copied the character and pose from a famous original. It's better to be the greatest artist you can be than a second-rate version of anyone else.

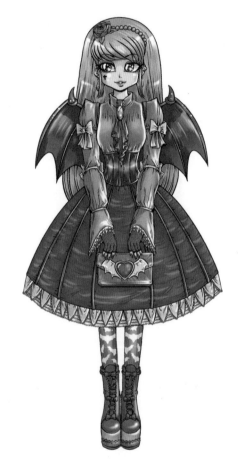

THE ADVENTURE BEGINS

Creativity is an adventure you can embark on without any money and without leaving your desk or computer. You don't even need a publisher or printer – you can self-publish online while you build your reputation.

The artists in this book are sharing their experience to give you a head start on your own adventure. Manga fans everywhere are on the lookout for an amazing comic from a new talent – and with practice, dedication and creativity, it could be you.

HOW THIS BOOK WORKS

This book is here to help you develop or improve your manga art skills by studying how experienced artists create their own work. On the following pages you'll find projects of varying lengths and styles, presented by each artist in his or her own way. Some are very detailed and will take you a while to go through. Others are shorter, but packed with information and ideas you can use.

WAYS TO USE THE PROJECTS

Remember we talked about copying other artists' work to learn from it? Well, what about copying every project in this book, step by step?

This is a good way to try out the techniques and build your confidence, especially if you're just starting out in manga art. Without pressure to create a storyline or character, you can focus on improving your skills and learning as much as you can in the old-fashioned way, by imitating experienced artists and comparing your work with theirs.

You can also switch media. If a project is executed mostly or entirely in the computer, try copying it by hand and see how it turns out. This way, whether or not you have a computer with an art program, you can still practise and improve by copying the projects. Or take a project – maybe one of your own – done by hand, and try switching it into the computer, following the steps outlined by one of our artists.

Another way to switch media would be to take a look at the way our artists use photography, imported images and layers of texture in their work. You could have a lot of fun remaking one of the projects, or one of your own stories, using those techniques.

If you want to apply the learning to your own characters, you could start with a portrait or headshot. Try drawing one of your own characters using the techniques and poses in this book.

THERE ARE NO WRONG ANSWERS

In making a comic, your only goal is to tell your story in the best way you can. If you want to do a mecha battle story in the style of *shojo* manga, that's fine. If you want to tell a boys' love story using cute animals, or a ninja fighting epic using household implements, that's fine too. Manga can be anything, do anything and go anywhere. So check out the very different styles and ideas from our artists, and then let your own imagination run wild.

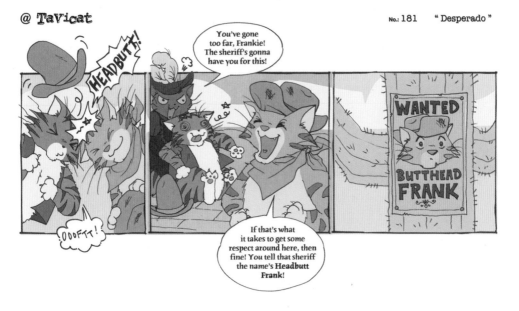

Drawing skills

HEADS & FACES

Drawing heads and faces takes a bit of practise, but once you break it down into steps it's easy. Start drawing: give the faces an egg shape, which can be fatter or thinner depending upon the desired facial types. Oval and heart-shaped faces are conventionally beautiful; round faces are cuter; square faces tend to look distinguished and handsome.

DRAWING HEADS AND FACES BY SONIA LEONG

Step 1

As Manga can exaggerate and minimise some parts of the face more than real life, I find it useful to break the head into two sections, a round, spherical top half and a jaw/chin underneath. I draw a horizontal line across the circle halfway to represent the brow bone, then I add a **vertical centre line** down the middle and extend it as needed below the circle until I achieve the right face length. Then I join the sides of the circle to the point of the chin to make an egg shaped template.

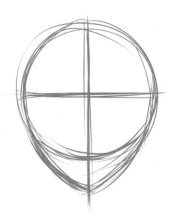

Step 2

I add a few key relative measurements to help with placement of the features. The tip of the nose is halfway from the brow bone to the chin, so I place a **marker** halfway from the cross in the middle to the bottom of the egg. From that nose marker to the chin, divide in half for a mouth marker. The ears are sized and placed in between the brow bone and the nose marker. Finally, the neck should be a minimum of a third of the width of the head and increased to match your character (thicker if male, older, more muscles).

Step 3

Once you have the template with markers, it's relatively easy to size and place the facial features. Eyes go below the brow bone, eyebrows go above. The nose is drawn on the nose marker, the mouth at the mouth marker. Ears line up with the brow and the nose.

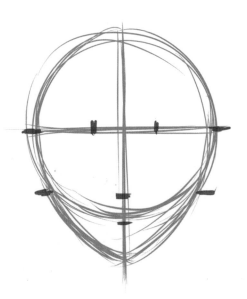

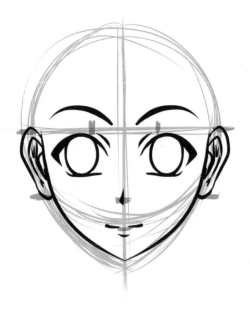

Step 4

As this is a young female character, I've drawn her neck at the minimum width of a third of the head's width. The finishing touch is hair and it is crucial that it sits well on top of the boundaries of the template, it should cover the top of the head like a wig. If in doubt, go bigger! Hair has volume so it always has to be bigger than the guideline.

Step 5

You can use the same set of guidelines for other views of the head if you rotate them accordingly. In the side view, the centre line goes down the edge of the circle, but otherwise the nose, mouth and ear markings are all the same. The only addition is that in a side view, the ear is placed two-thirds back on the head. When dealing with three-quarter views and beyond, you have to think about the guidelines in three dimensions; now you can see how the guidelines curve to match the egg shape. The main difficulty here is accounting for perspective; knowing how much to shrink or stretch the features like the eyes will take practice.

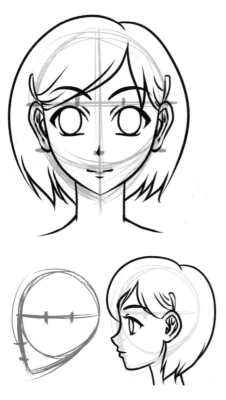

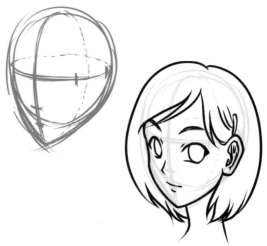

Artist Info: Images © Sonia Leong. Website: www.fyredrake.net

TWO FACES HAVE I
BY BRUCE LEWIS

Step 1

Since both of the girls I want to draw are good-looking (in this case; ugly faces are also fun to draw), I put down two ovals, then sketch in necks and ears. Be sure to create interesting positions for the heads; no one wants to look at police mug shots. To the lightbox!

Step 2

Centerline and equator go in next. Note (A) that the equator must be at or just a bit above the ear; the pupils will be centered top-to-bottom on this line. Note, too (B), where I adjusted the length of the chin; the equator should (obviously) be halfway down the length of the face as measured from crown to chin. Sketch in basic facial contours here as well.

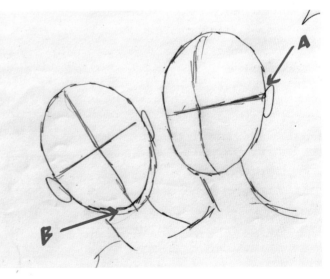

Step 3

Lightbox again. My first swipe at the faces. Note that eyes are one eye-width apart and one eye-width (keeping perspective in mind) from the temples. I also sketch in the hair and shoulders.

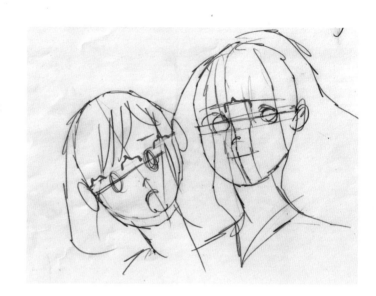

Step 4

The image drawing. Here I redraw the image on the 'box and add in all the details and try to capture the 'feel' I want. At this point I'd like to stop drawing, since I find this stage best captures the freshness and energy behind the story I want to tell with this picture. Sadly, however, this sketch is nowhere near complete nor ready to print. *Onward!*

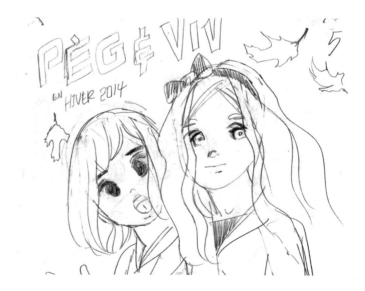

Step 5

First clean up. Slicker, but
too much like colouring-
book art. This drawing
needs more verve.

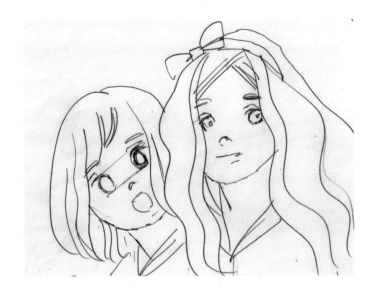

Step 6

Flip! Turning the drawing
over, I use the lightbox to
detect errors in anatomy and
perspective, e.g., uneven
features. I then sketch in
corrected anatomy/
perspective on the backside
of the paper.

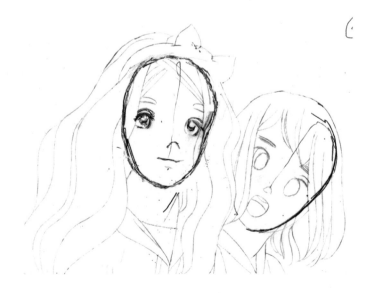

Quick Tip: If you don't have a lightbox you can use a really low-tech trick – tape your drawing to a windowpane so the
sunlight comes through it.

Step 7

Second clean up. I redraw the corrected, reversed image onto a new sheet of paper. Done carefully, this produces an almost exact (reversed) copy of the first clean up.

Step 8

The finished piece. The second clean up is flipped and redrawn in pen or (in this case) pencil. Two faces have I, ladies and gents!

Artist Info: Images © Bruce Lewis. Website: www.brucelewis.com

ADDING COLOUR TO FACES – CAT-GIRL BY CHIE KUTSUWADA

Step 1

Make a rough drawing with as much detail and precision as possible. Usually I do everything digitally. The program used here is called Clip Studio Paint, a hybrid of Manga Studio and SAI. Most of the techniques I use here will work in SAI or Photoshop as well.

Step 2

Finish the line drawing on a new layer. Some parts are drawn by hand and some, such as the hair and the neckline which I want to make very smooth, are done by the Line tool.

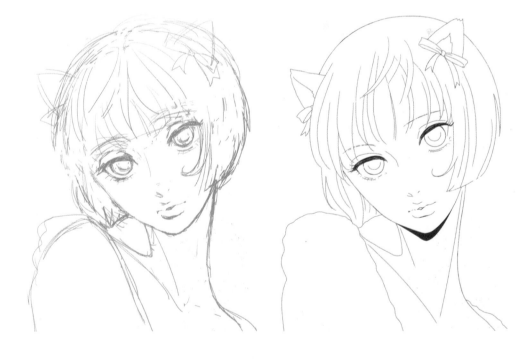

Step 3

Flat paint the face on a new layer underneath the line drawing layer. Put the girl's top and her cat ears on another new layer, using the **Bucket** tool or **Big Brush** tool. You can see that the skin colour goes over the hair area and the eyebrows are drawn quite thick, but do not worry, there will be a new layer for the hair colour on top to cover them.

Step 4

Use the Select tool to select the hair area. Here I use the Gradation tool to colour the hair. It's a good idea to create and save your own gradation colour palettes in the program you use. Lightly erase the edge of the bangs and some tips of the hair to enhance its lightness.

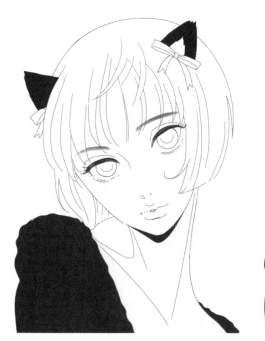

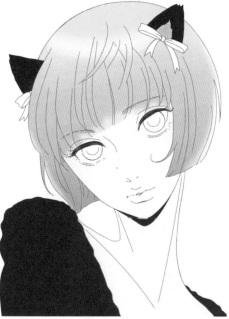

Quick Tip: Save your favourite colour palettes, gradations and tones for use in future projects.

Step 5

Create a new layer and add the shadow for the skin using a natural pinkish dark skin colour. Use both soft edges shadows and sharp edge ones. The soft edge shadows on top of the nose and lips contrast with the sharp edge shadows underneath to create definition and shape.

Use similar but slightly rosier and paler colour to enhance the nose and around the eyes. Then I gave this layer **Linear Burn** status to give greater depth to the colour.

Step 6

Add the base colour to the eyes on a new layer. Some gradation of colours, darker top to lighter bottom, would work well. Then add some highlights. Finally, make a new layer and add the shadows to the eyes. Remember that the surface of the eye curves like a ball – your shadows need to create this effect. I use dark blue grey for the colour and make the layer status **Darken**.

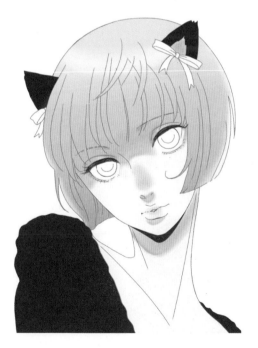

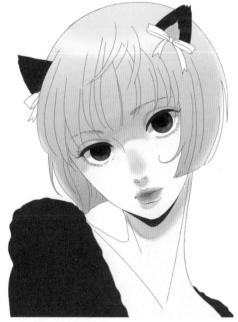

Step 7

Also create a new layer and paint the lip colour. I use some customized watercolour blushes. Take your time when you paint eyes and lips. If you do them right your character will look more impressive and attractive.

Step 8

Copy the finished line drawing layer (Step 2) and put it on top of the painted layers. Give this line drawing a slight **blur effect**. This makes the whole picture softer, which suits this artwork and also makes it look less digital. Also add some shadows around the face and hair in pale purple, on a new Darken status layer.

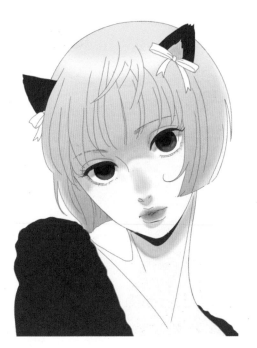

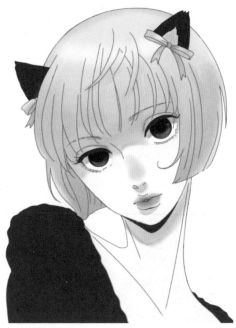

Step 9

Use another new layer for the highlights. I find the highlights are very important to make a character alive and sexy. Use blurred highlights as well as sharp white dots. Remember how the two kinds of shadow (Step 5) give definition to the features? The two kinds of highlight work in the same way.

Also consider where the **light source** is in the picture. Adding not only white highlights but also **neon colour highlights** works nicely, especially in the eyes.

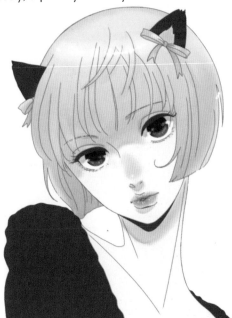

Step 10

The completed work. Add some background and atmospheric white clouds/lights, and it's ready. Quite often I use **copyright-free**, ready-made images or materials for adding some accent on the background, like these flowers. But please don't forget to check the terms and conditions on any materials you find on the internet or books before you use them. You don't want to steal another artist's work!

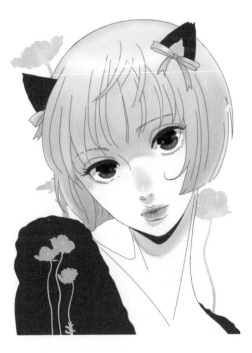

Artist Info: Images © Chie Kutsuwada. Website: www.chitan-garden.blogspot.com

FIGURES

Once you've mastered faces, you'll want to master the basics of drawing whole figures, in correct proportion and in different poses, whether that be seated comfortably or ready to spring into action.

ACTION POSE BY INKO

Step 1

On a manga character drawing, I am sure artists want to depict their characters as attractive and appealing in their ways, so best to avoid drawing your characters standing straight or with a dull expression unless these are part of his or her uniqueness. Sketch out a character in both full body and facial close up – let your imagination go wild with poses and expressions.

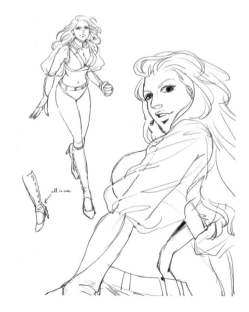

Step 2

Decide the most effective posing for your character. Here I chose a running pose. Draw a rough sketch in Clip Studio Paint with **Thick Pencil tool in Blue**. She is an invincible fighter, but appears feminine and sexy, and this is one way of depicting a 'feminine' running pose. She does not bend too far forward so that you can show all her features of the costume and her face. Make sure her limbs don't hide other parts of her body.

Step 3

Set the opacity of the sketch layer to 50%, and create a new layer. Start inking on the new layer with **G-pen tool in Black**, making sure that you show how the character's hair and light materials of the sleeves are affected by the air passing through because she is moving at high speed. Those little details really make a big difference on action character drawings.

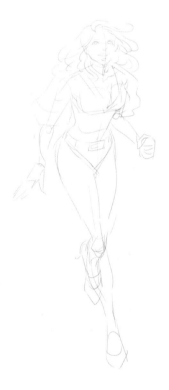

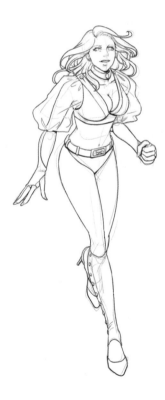

Step 4

On a new layer, fill colours by the Colour Bucket tool section by section. You notice how 'still' the drawing looks now. The flat colouring you get from the Bucket tool makes the image very quiet. But you can change it by shading it in the next step.

Step 5

Air Brushed colour on her skin, Yellow and Pink glow on her costume, and light effects on her hair were added on a new layer. She started looking 3D and more human. Her dancing hair reminds us of the air streaming past her as she runs. The light reflections show she's wearing shiny materials.

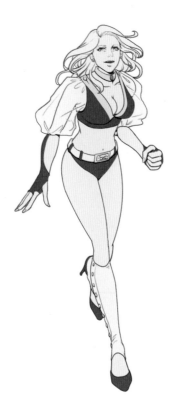

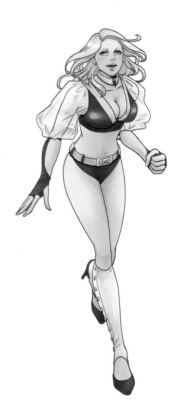

Quick Tip: Remember you can mix and match different styles of character drawing in the same manga, especially if it's a comedy or fantasy. Superheroes, super deformed, chibi and cute characters can all be part of the same story.

Step 6

Set a new layer as **Add (Outer Glow)** and give her some extra shine. Make her eyes sparkle naturally. Make her cheeks, lips, hair, buttons and accessories shine and glitter.

Step 7

Set a new layer as **Overlay** and enhance the colours even more by using the Airbrush tool. Pink shades on her skin, and light blue on edges of hair and the costume help to make the theme colours (Yellow and Blue) stand out beautifully. She looks like she attracts and reflects lights on her body while she's running. Finally it is done!

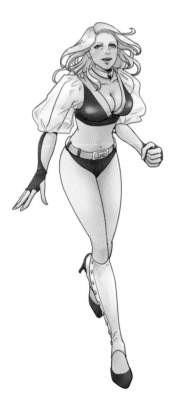

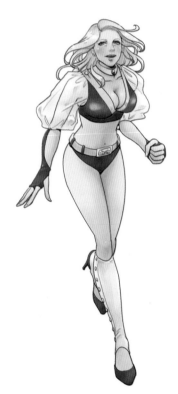

Artist Info: Images © Inko. Website: www.Inko-redible.blogspot.com

DRAWING A SITTING FIGURE – POWDER BY SUMMER CRUZ

Step 1

This project is entirely made in the computer, but I still have to start with the basics. I use the **pencil brush** for the art program I'm using, in a random colour, and sketch the basic shapes and pose of what I want the character to be and be doing. If you want to do this stage in pencils on paper, choose a light blue pencil that won't show up when you scan your sketch in to the computer. See how I've used circles to show the positions of the joints – the shoulders, elbows, knees, and hips? This helps me keep the pose natural and correct.

I also do a rough sketch of the background before I sketch the character, to get a better sense of where they are in the picture.

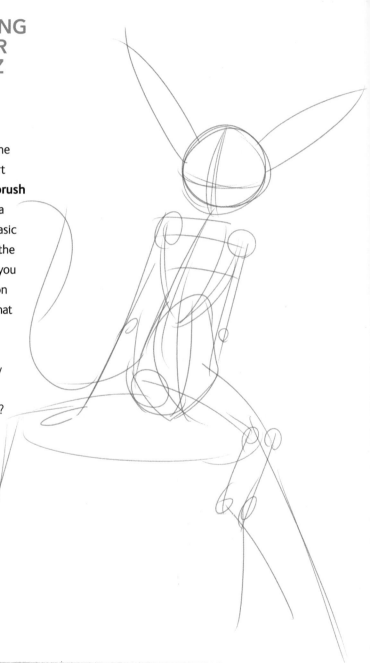

Step 2

From there, I **lighten the layer's opacity**, and sketch over it on a new layer, adding more detail and putting the flesh on the skeleton. I'll sometimes use two colours, so I can see what I wanted tweaked in the second round of sketching.

Step 3

I now lighten that layer's opacity, and do the line art. I like to use different brushes for the lines, depending on how I want it to feel. For this one, I use the **Pen tool** to give it crisp lines and a more serious feeling. A brush gives softer, more fluid lines.

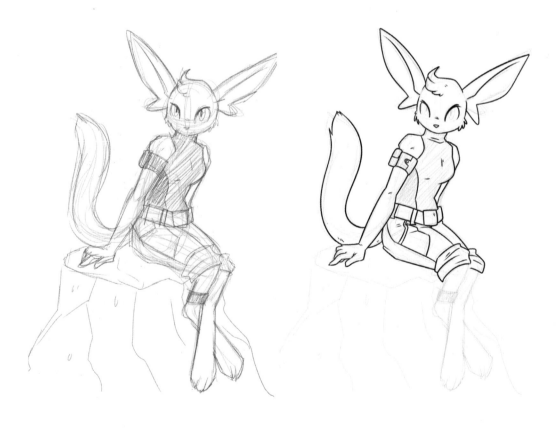

Step 4

Now we get to the second biggest part of the picture – the colours. I use the Selection tool and click within the line art, and fill it in using the **Bucket tool** with the colour of my choice. I usually do this stage on a new layer beneath the line art, to make it quicker and easier to colour in bigger spaces. Once I've done that, I zoom in and go over it with the pen to fill in the spots that the selection and bucket tool missed. I also lay down my background colour to make sure they all play together nicely. The beauty of doing this in the computer is that you can change the colours so easily.

Quick Tip:
Even if you're working in a fantasy setting, adding in elements of nature, such as the way light falls, gives people looking at your art a stronger sense of its reality.

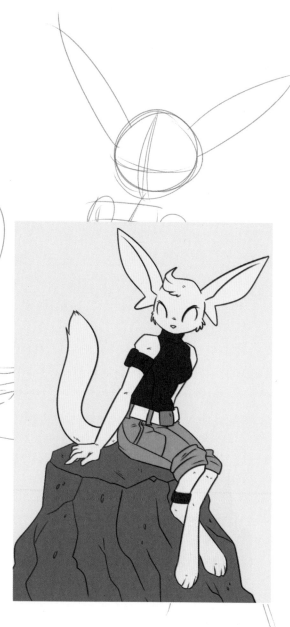

Step 5

If I'm going to add any shading to this, I now play around with the direction and intensity of the lighting, and how I want to put the shading/lighting down. For this picture, I use the **watercolour brush** to get smooth transitions and make a nice contrast with the sharp line art.

Step 6

Looking good! I've got my colours down, my light source and direction figured out, and shading added. I'm going to keep using the watercolour brush and make the background a clear shot of the sky with some nice, lightly textured clouds.

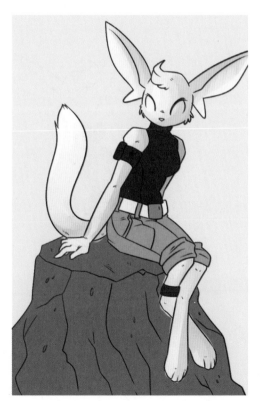

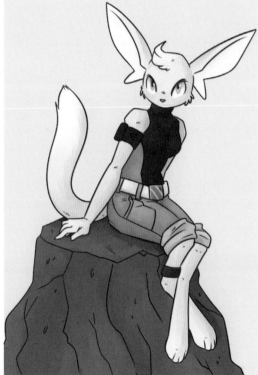

Step 7

I make the sky lighter the closer it is to the 'ground', to show where the horizon is. The horizon is usually the lightest part of the sky.

Step 8

Finally, on a different layer, I lay down the basic shapes of the clouds. The great thing about them is you can make them as lumpy or as smooth as you like – clouds come in all kinds! I keep them a little messy and loose, and mix in the colour of the sky and the colour of the ground in them, to show that they are reflecting light and having light reflected upon them.

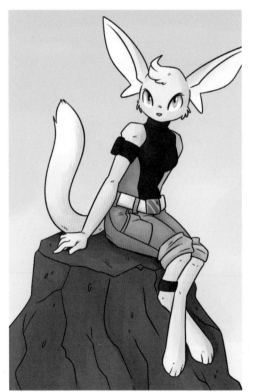

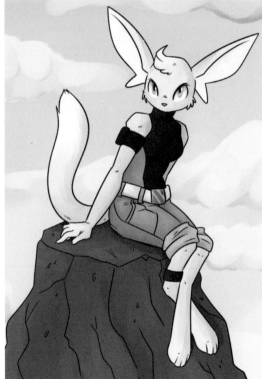

Artist Info: Images © Summer Cruz. Website: www.purrcipitation.tumblr.com

STYLES & TECHNIQUES

Manga can come in a variety of shapes and sizes – the artist has to decide on the medium, and the most appropriate approach for the subject. Colour or monotone? Paper or digital? And what about the style?

SUPER DEFORMED ABE BY BRUCE LEWIS

Step 1

Folks often get the terms 'Super Deformed' and 'chibi' confused. To my mind, the difference lies in the whimsy level. A Super Deformed (SD) character is, to my way of thinking, a kind of caricature – a deformation of the subject's face and form for humorous purposes. For example, let's say I want to do an SD drawing of a real person. Of course, the first name that springs to mind is Shinz Abe, Japan's beloved Prime Minister.

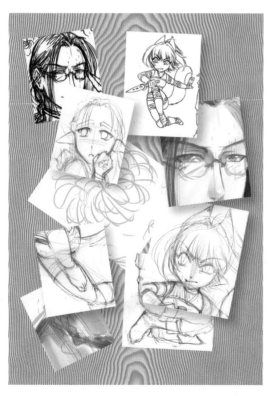

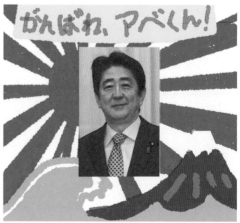

Step 2

First, I sketch in the figure – about three 'heads' high. Since SD cartooning is Big Head cartooning, that means Abe-sensei's torso and legs should be drawn about the same size as his noggin.

Step 3

Next, I sketch in the pompadour hairstyle and detail the figure. Note that the hair isn't quite right. I also give the PM little 'Sgt. Frog'-type legs. Always good for a laugh!

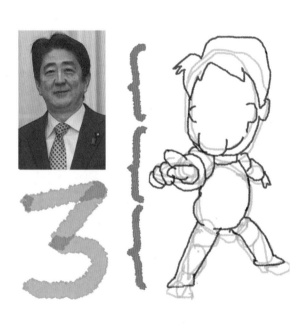

Quick Tip:
Even if you're working in a fantasy setting, adding in elements of nature, like the way light falls, gives people looking at your art a stronger sense of its reality.

Step 4

Fun time! I get to detail the face, uniform, etc. He sort of looks like the Japanese Ronald Reagan. The hair is still not quite right.

Step 5

The finishing touches. I fix his hair, paint in the colour, and add a typically moronic pun to the background in order to let everyone know I'm hip to the current Japanese political scene and extremely clever. This actually turned out better than I thought it would...

Artist Info: Images © Bruce Lewis. Website: www.brucelewis.com

CHIBI CHIBI CHIBI
BY BRUCE LEWIS

Image 1

In my opinion, the big difference between Super Deformed manga art and Chibi art lies in the area of stylization – that is, the simplification of the image of the subject of the image to its most fundamental level. SD art is still, in some sense, illustrative art; it represents depiction. **Chibi art**, on the contrary, is something more like a **symbol** of the subject at hand and less like a depiction. A chibi baby, for example, is less a caricature of a baby and more an ideogram that means 'baby'. Catch the difference?

Image 2

In like manner, the form of an actual cat is distilled beyond any attempt to show what the cat looks like; it seeks instead to show what the cat is – its essence, its 'catitude'. This is what you are trying to do when you draw something in chibi style.

Chibi

Actual baby

symbol of a baby

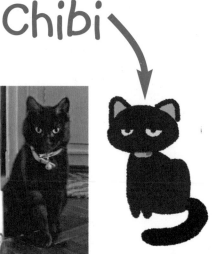
Actual cat

symbol of a cat

Image 3

When in comes to the human form, chibi represents the distillation of man down to an infant level (which is fine; Chibi means 'kid', anyway). The basic chibi-style cartoon body features a shorter, more oval skull, with big eyes (A), tiny arms and legs (B), and a plump jellybean-style body (C). In other words, it's baby like – which is why most people think the style is cute.

Image 4

The childlike chibi proportions adapt well to an older, male character.

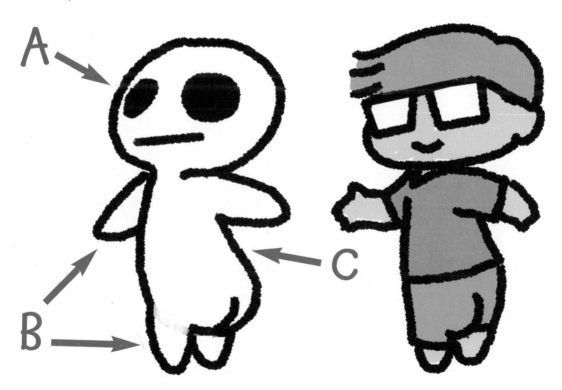

Image 5

When drawing larger and/or more detailed chibi characters, you may take a more illustrative approach than normal. Note the fat cheeks, big eyes and subtle smile of the baby combined with the symbol for manly facial hair.

Image 6

And when adding colour to chibi characters, it's sometimes a good idea to apply it in a **naive way** rather than with any kind of subtlety or delicate shading.

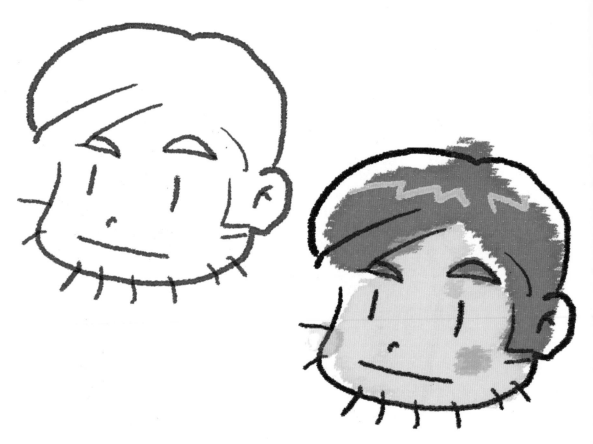

MAGIC MARKER TUTORIAL BY SONIA LEONG

Step 1

Start with a pencil draft of the final drawing on **smooth board** or bleedproof paper, something that isn't too textured. Use very light strokes as you don't want to make too many marks on the paper and it has to be easy to rub out later.

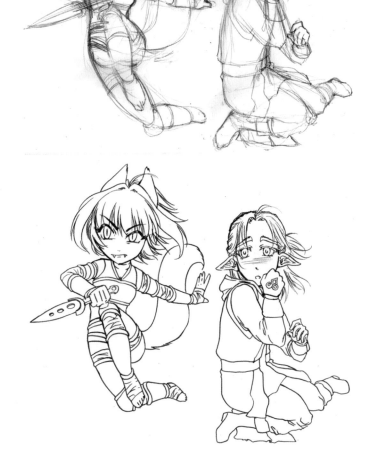

Step 2

Ink over the lines with a **marker-proof pen** – you want something that is resistant to alcohol-based markers. I used a ZIG flexible fineliner that allows for thin and thicker lines. Try to vary your line widths to give your art more depth. If you are not confident about keeping your colouring within the lines, err on the side of thicker lines throughout to give yourself more breathing room.

Step 3

Start colouring by laying down a few light bases. These are the lightest shades any soft, matte areas will go. I'm using **Graph-It markers**.

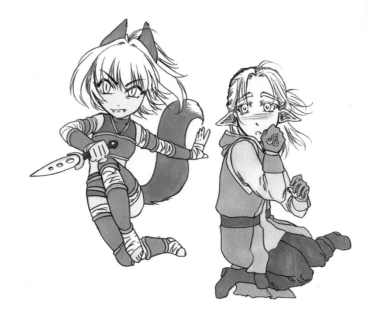

Step 4

Add shadows in bit-by-bit, using shades that are two or three levels darker to make sure that there is sufficient contrast. Use markers that have brush tips so that you can feather your strokes out and improve blending. I always start with the skin as that is the most challenging and subtle surface to shade, so it helps me gauge how much contrast and shading to use on the other areas.

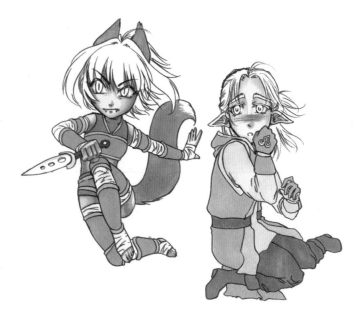

Step 5

Continue to add shadows to the rest of the image. Most clothing and fur is more matte than hair or metal, so you don't need as much levels of shading in the former than the latter. Try to use the white of the paper to create highlights where you can, this is particularly effective with hair.

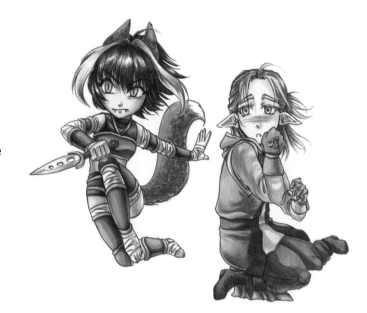

Step 6

For the final touches, add white ink highlights on the eyes and some of the hair, and to provide a background to emphasise the space they take up and the positions they are in. Shadows on the ground help to show the character on the left is leaping away and lines behind them emphasise speed and direction.

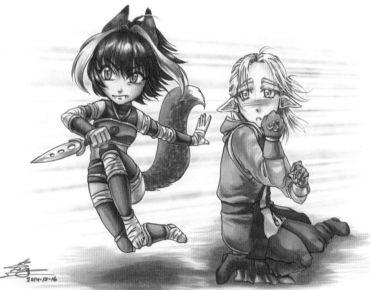

Artist Info: Images © Sonia Leong. Website: www.fyredrake.net

DIGITAL PAINTING IN SAI BY SONIA LEONG

Popular digital paintings in manga style usually have very neat, precise lines and soft, blended colouring. To do this, ideally you should use hardware that responds to pressure sensitivity (like a **graphics tablet** or tablet computer) and software that lets you ink and colour in separate layers, such as **PaintTool SAI**.

Step 1

Start off with a rough sketch on a blank layer.

Step 2

Reduce the **opacity** of the sketch layer down to around **20%**, then add another layer underneath it. Change your brush setting to soft colouring, like the preset Watercolour tool or some other brush where pressure affects opacity strongly and size weakly. This lets you lay down some test colours very quickly, just pick one or two colours for each section and press harder if you want the colours to look darker and stronger. When you've laid down some colours, you can easily adjust and paint over the existing brush strokes without messing them up by locking the layer opacity. When you're happy save this layer for later.

Step 3

(*See* image on previous page). Now you work on getting the lines neat and thin. Using an appropriate brush setting (thin, with opacity set to max and size linked strongly to pressure), start inking over your rough lines on a new layer. Only ink the minimum you need. **Lock the layer opacity** and using the rough colours as a guide, tint the lines with a **soft airbrush or watercolour**. Set this as the top layer.

Step 4

For the final colour layer, go back to the rough colour layer you did earlier and use it to pipette the exact colours you need for precise shading and fills. Carefully fill the areas and keep within the polished lines. For the best effect, use soft, blended fills for general shading, then add sharper, darker shadows in the areas that need them. To leave outlines around your brush strokes automatically, in PaintTool SAI you set a **Paint Effect 'Fringe'** and choose how thick the outlines can be.

Step 5

(*See* image on opposite page). Finally, add the background on a separate layer (or more if you need it) underneath everything. It isn't always appropriate, but the feel of this image is quite dreamy, with lots of white highlights, so having areas that fade out into bleached sunlight is fine. Lock the opacity as you need to for adjusting colours. When your background is done, add one last layer on top over everything to extra highlights, sparkles and wisps of hair.

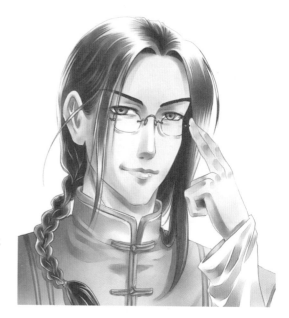

Quick Tip: Experiment with different weights/ thicknesses of line on a separate layer so you can easily remove it if you're not happy with the result. Only lock your layers when you're completely satisfied.

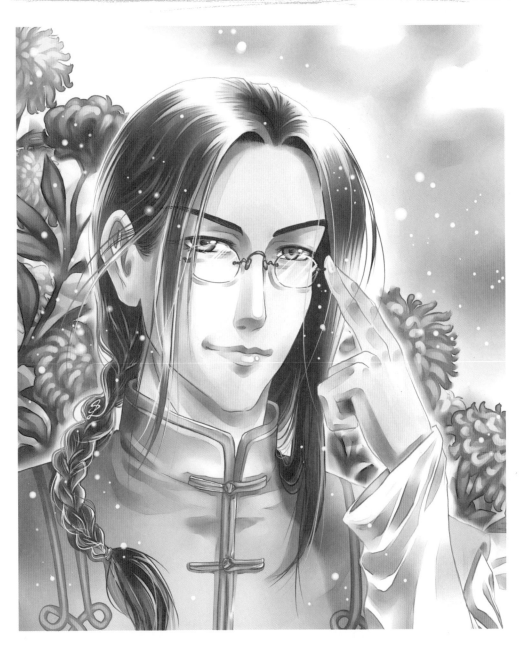

Artist Info: Images © Sonia Leong. Website: www.fyredrake.net

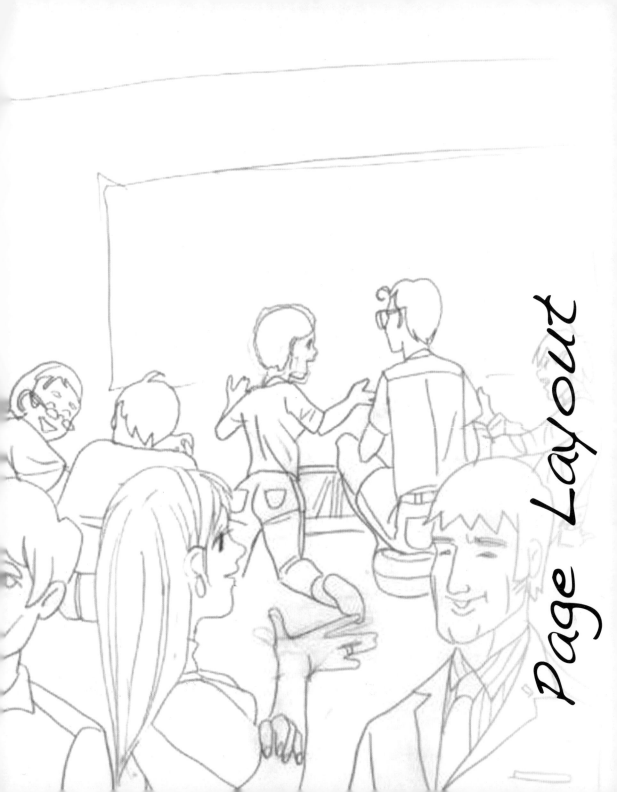

Page Layout

FROM DRAWING BOARD TO FINISHED PAGE

Bruce draws the roughs at the kitchen table, desk, or wherever he happens to be, and the finished pencils on a cheap lightbox he bought at a hobby store. In his work area is a computer for research, scanning, Photoshop/ Illustrator and file generation. He then does all the art with a graphics tablet and stylus.

A SPREAD BY BRUCE LEWIS

Step 1

I rough out the whole story in advance on 8.5 x 11 in bond paper (i.e. **copy machine paper**), making sure the action flows across the spread in an easy-to-read manner. I save the dialog until the lettering phase.

Step 2

I'm doing a spread here, so I rough out the entire two-page image using two pieces of 8.5 x 11 in 6-# **card taped** together instead of one big piece. I use the lightbox to do several iterations of pencils until I get the look I want. The result is two pages of roughed pencil.

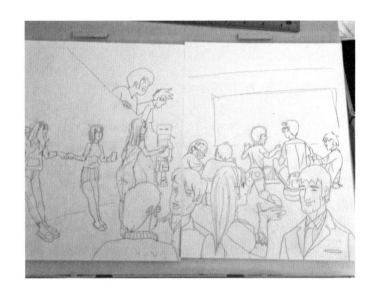

Step 3

I separate the roughs, then staple a piece of blank card on top of each one.

Step 4

The stapled pages are placed on the light box, which is then fired up..

Step 6

The rough art for each page of the spread is then traced to produce the finished pencils.

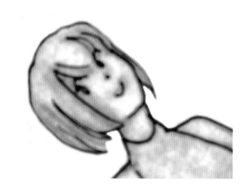

Step 5

...rendering the top sheet translucent.

Step 7

The final product: two pages of 'slick' pencils ready for light box inking (traditional method) or digital 'inking' (the method I use).

Step 8

The actual size of the artwork
is 11 x 17 in, but my scanner is
only capable of scanning 8.5 x
11 in paper, so I draw the rough
pencils on two pages of that size
that I have taped together on
the back side. I then separate
the pages and scan the left-hand
page of the spread at 600 dpi
resolution. I save it as a
greyscale Photoshop image,
sized and trimmed to 8.5 x 11 in.

Step 9

The right-hand page of the spread
is then scanned in and saved with
the same characteristics.

Step 10

I then open up a new Photoshop
document (greyscale, 600 dpi,
17 x 11 in) and paste in the
two spread pages, left...

Step 11

...then right. I flatten it all and
save it.

Step 12

I Duplicate Layer, then create another layer on top for inking. The Background Layer is blanked to provide an opaque background for the art (Select All, delete to background colour). and the pencil layer's opacity is dialled down to 30–40% or so.

Step 13

I go to Brush palette and create a suitable Pencil point.

Step 14

Using the Pencil tool and the tablet/stylus, I then 'ink' the drawing on the top layer.

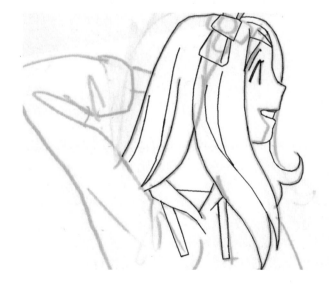

Step 15

Once the entire drawing is
embellished and cleaned up, it's
time for digital screentone. For
each value of screen I wish to
use, I create a separate page
(greyscale, 8.5 x 11 in, 600 dpi),
then Fill with black (K, at the
desired percentage, e.g. 25%).

Step 16

I convert the greyscale page to
a **bitmap at 600 dpi**, halftone
screen. The frequency is
adjustable based upon the
density of grey you want, but I
keep it below 85 lpi due to dot
gain (which you have to assume
is going to happen on the press).
The angle should be 33–45
degrees or so, with round dots.

Step 17

Convert back to greyscale, and
lo! A page of digital screentone
appears! This is your source
document for your Rubber
Stamp tool, so sample the
pattern now.

Step 18

Switching back to the spread,
create a new top layer, and then
use the **Rubber stamp tool** to
'paint in' the tone as desired.
Once you have the entire
spread toned (and do take it
easy – overuse of tone looks
bad), Save As a copy, Flatten
Image, then save as a greyscale
TIFF file with LZW compression
(reduces file size).

Step 19

I do my **lettering in Adobe Illustrator**. Open a document (size 17 x 11 in), paste in your TIFF, then Lock it down. Pick an easily legible typeface ('font'), type in the words, then create and size ovals (or whatever) to enclose them. Draw in the tail of the word balloon, position it, then use **Pathfinder** to meld balloons and tail together. Fill with white, stroke with Black (2–5 pt), and then Bring to Front and position as desired.

You know, Peg, ol' Trampolina Steemer was right about one thing. There really is a place for people like her -- people who want to **regulate** the entertainment biz on the basis of "social justice".

That place is, of course, NORTH KOREA.

Step 20

All this done well, and your spread is finished! Save it as a PDF (fewer problems at the printer that way) and back it up. One spread finished and ready for printing!

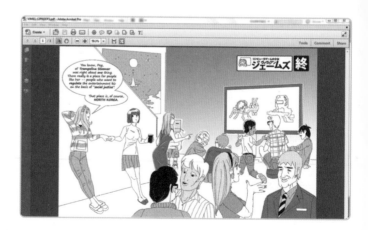

Quick Tip: Images © Bruce Lewis. Website: www.brucelewis.com

MIXING DRAWN AND PHOTOGRAPHED ELEMENTS

Starting with an epic step-by-step walk-through of page creation from basic sketch on the drawing board to the PDF page proof of the finished work, you'll observe how important it is to make your page as good as possible at every stage in the process.

A PAGE BY DAN BYRON

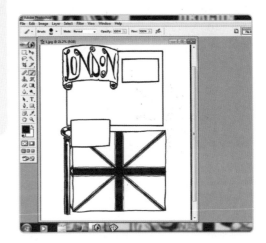

Step 1

I start each page by drawing the layout as a standalone piece, then scan it and open it up in my old copy of Photoshop 7. I've been using it for years and never needed to upgrade.

Step 2

Next I use bright colours to fill all the elements of the page I want to remove – like a green screen in a movie SFX shot.

Step 3

I'll use the Background Eraser tool on all the brightly coloured parts.

Step 4

Now it's ready for me to add more elements. I had previously decided I didn't like the style I wrote 'London' in...

Step 5

...so I use the Brush tool to get rid of the old one...

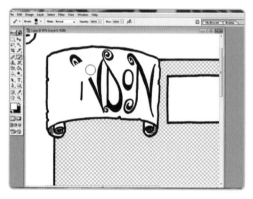

Step 6

...and I'll replace it with this one I made earlier.

Step 7

Again, I use a bright colour and the Background Eraser tool to get rid of it.

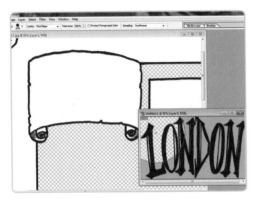

Step 9

I open more of the drawn elements, and again pick a bright colour to fill the areas I want gone.

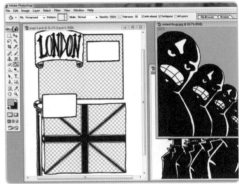

Step 8

I then drag and drop the image and resize it.

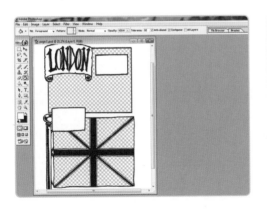

Step 10

After that I drag and drop the image and resize it to fit.

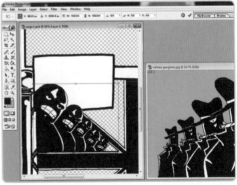

Step 11

I repeat this process several times...

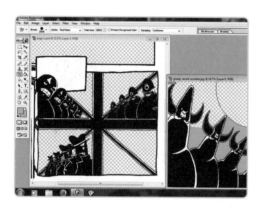

Step 13

Usually all drawn elements of the page are in the foreground, so once they're in place I'll open all the photos I want to use as backgrounds for the page.

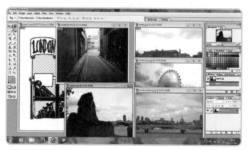

Step 12

...until all drawn elements are in place.

Step 14

I then just drag and drop an image, like I did previously with my artwork.

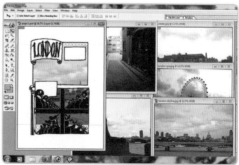

Step 15

I'll mess around with resizing it for a few minutes until it resembles what I'd originally had in mind.

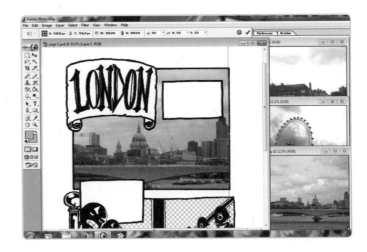

Step 16

As before, I repeat the same process until all backgrounds are in place.

Step 17

Now everything is in place I can finally add the element that I created way before the rest...

Step 18

... the script! I think it's best to keep most of the text the same size throughout your manga, but sometimes I'll use alternate text sizes and fonts for dramatic effect when a character shouts or screams.

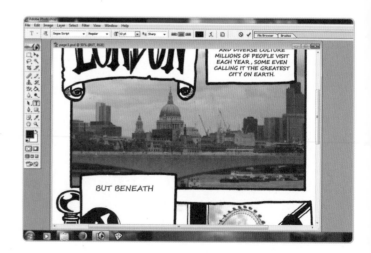

Step 19

Once I've flattened the image and converted it to black and white, the page is complete. This one was relatively simple, there were no visual effects, sound effects or speech bubbles.

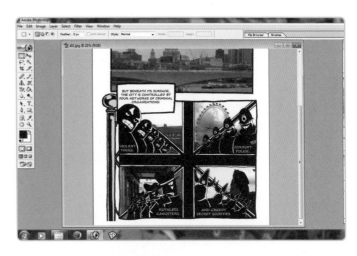

Step 20

It always feels good to finish a page!

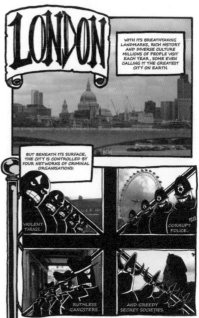

Artist Info: Images © Dan Byron. Website: www.facebook.com/badeggcomic

Pagemaking Step by Step

CREATE YOUR PAGE

Most Western cartoon strips run panels in the same style as Western text, side-by-side and left to right. Japanese is traditionally written from top to bottom. **This opposite way of looking at the flow of action is one of the most interesting things about manga-style comics.**

MAKING A PAGE IN COLLABORATION BY CHIE KUTSUWADA

This is a page from *Two Sons*, a collaboration work with Richy K. Chandler, writer and letterer, and Inko, who did paneling and the rough sketches for this page. As you can see, three of us discussed the layouts in quite some detail at this stage.

Quick Tip:

When you're working on a collaborative project, discuss the finished script and the lettering positions with the letterer before you start work on the page. Then you know how much room to leave for lettering and dialogue.

Step 1

Think about the positions of the speech bubbles that create the pace of how the story goes. This page is done digitally and the program used is **Clip Studio Paint**.

Step 2

Here I draw more precise roughs. I use so many different layers, cut/copy and paste; move things around in order to get everything as right as possible. Take your time to adjust roughs. After working on one panel, do not forget to look at the whole page to **see the balance as a page**. When I draw human figures, I quite often draw a naked body first, then add its clothes on. It is useful, especially when the pose is complicated.

Step 3

Create a new layer and draw the panels. Then copy this layer and start inking on it. Start inking with the main figures, which control the balance of the each panels. Use the thicker line for the shadowy parts and thinner line for the detail, such as hairstreaks, sweat and creases.

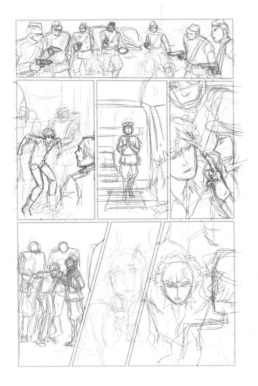
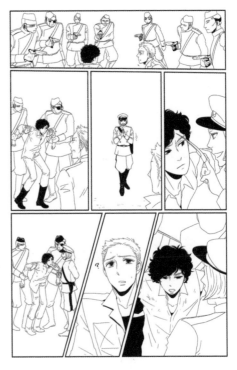

Step 4

Add background and more detail. Usually I use a thinner and less pressure sensitive pen for the background. Always checking the balance of the page. For my personal preference, I do not think every panel should have background. However, at least one panel in a page should have a quite detailed background to show the whole situation of the story.

Step 5

Use the **Paint Bucket tool** and **Select tool** to paint black area. When the character's costumes are black like this page, it might be a good idea to erase off some part around the edges/creases of the garments, such as the edge of collars in order to prevent the image becomes too heavy.

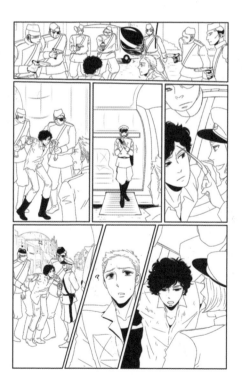

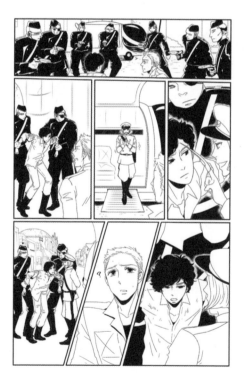

Step 6

Add shadows and tones. Using digital tones only might make the picture too stylized or hard, so I prefer adding some **hand drawn lines** for shadow and/or to give some textures. It maybe a good idea to do some exercises on drawing even parallel lines. Once you are accustomed to drawing steady even lines, this skill is adoptable for drawing hatching etc.

Step 7

The speech bubbles are added by the letterer and completed.

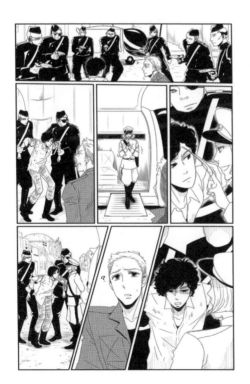

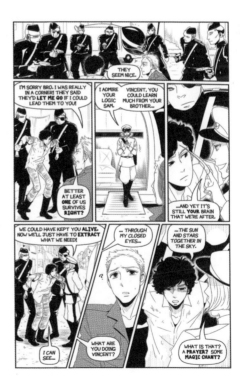

Artist Info: Images © Chie Kutsuwada. Website: www.chitan-garden.blogspot.com

FOUR-PANEL STRIP CARTOON BY SONIA LEONG

Step 1

A *4-koma* comic strip is a little different to put together than stand alone illustrations or general comic pages. Here, one character is gleefully introducing her own erotic *Yaoi* comics to her friend for the first time. It's a gag comic, so concentrate on getting your text to fit and for the joke to work across four vertical panels laid out vertically.

BOTTOMS UP

SO WHAT
DO YOU
THINK,
SIMONE?

BUT IF IT'S
GAY MEN,
WHY IS THIS
ONE A GIRL?

NO,
THAT'S
THE UKE.

UMM...

OKAY,
LET ME
EXPLAIN.

THE SEME IS
DOMINANT, THE
MANLY MAN IN
CHARGE, THE
ONE ON TOP.

IN CONTRAST,
THE UKE HAS A
MORE FEMININE
APPEARANCE,
BECAUSE HE IS
SUBMISSIVE...

...DELICATE,
WEAKER, THE
ONE THAT IS
PURSUED, THE
ONE ON THE
RECEIVING
END...

...THE
BOTTOM.
QUITE
LITERALLY.

AS YOU
CAN
SEE.

Step 2

If working digitally, you have a lot of opportunities to keep things on separate layers and to copy, move or transform text and images. So take advantage of this when working on your draft layer. I resized and shifted the characters so that they worked with the text, shifted the text to fit around the characters and copied the first panel to form some of the fourth.

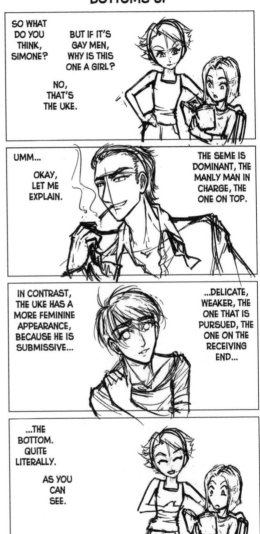

BOTTOMS UP

Step 3

Create a new layer and ink cleanly over the draft layer. You may find it helpful to bring the **opacity** of the draft layer down to around **30%** so that it doesn't get mixed up with your final inks. Make sure that the speech bubbles you draw are clean, round and overlap correctly to match with whoever is speaking.

BOTTOMS UP

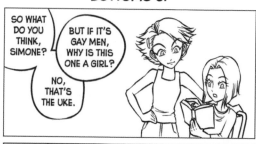

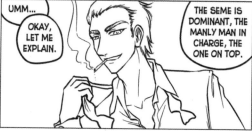

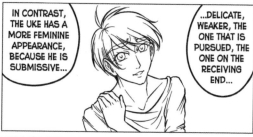

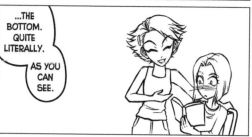

Step 4

Start colouring the character artwork on another layer. There are two styles of colouring used here: the real world (panels one and four) is painted and blended richly, whereas the world of the comics being talked about (panels two and three) are done lightly, **marker style**, with only the shadows concentrated on.

BOTTOMS UP

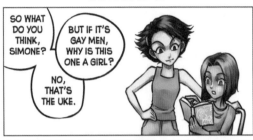

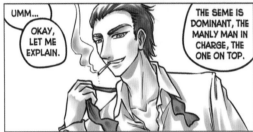

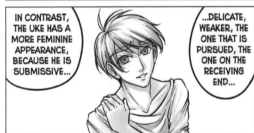

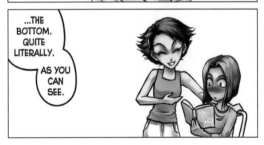

Step 5

The final touches are highlights and backgrounds. The inks are thick and clean enough to make it easy to select the areas around the characters and insert gradients, fills, patterns and so on.

BOTTOMS UP

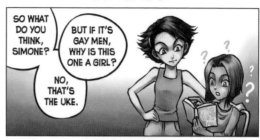

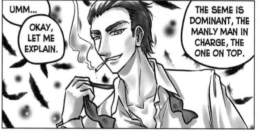

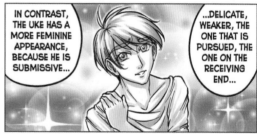

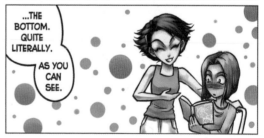

Artist Info: Images © Sonia Leong. Website: www.fyredrake.net

MANIPULATING PHOTOGRAPHY BY TONY LUKE

Image 1 –
Break The Rules

My editor at Kodansha impressed an important fact upon me whilst I was working on the *Dominator* serial for the anthology *Comic Afternoon* back in 1993; 'Manga artwork should have no limits and no rules – what's important is the energy and attractiveness'. Afternoon had long been a pioneer of rule-breaking with its publication of mind-bending stories whose art didn't fit into the conventional view of 'what manga should be', and thus the twisted photographic collages of *Dominator* was a sure fit.

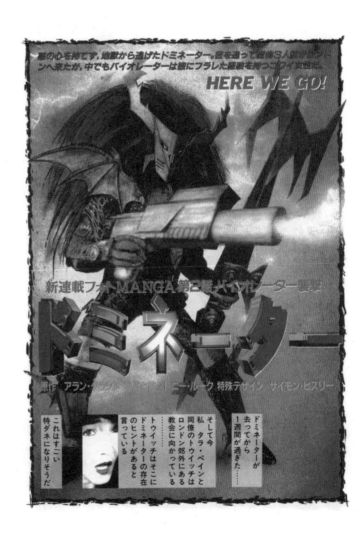

Image 2 – Old-school Artwork

How you achieve a final image should be a personal journey resulting in a unique final expression. Can't draw? Not a problem. You simply find a different way to tell your story and depict your characters – don't be put off by anyone telling you that 'you aren't doing manga the correct way'. There is no correct way – only the final result matters. *Dominator* was created using **scanned** and **printed photographs** of poseable foam-rubber animation models and live actors, which were then **collaged**, painted and airbrushed onto to create the final pages. At no point was a computer used – these were the days of scissors and glue and good old acrylic paint!

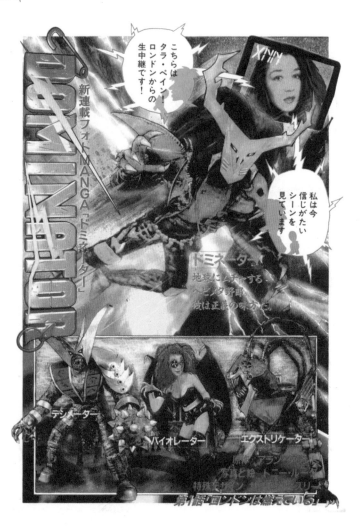

Image 3 – Play With Materials

Here I use an assembly of photos pasted up on a scanned and painted background. Notice how the 'real world' character is in black and white, and how the speech bubbles show the link between him and the woman in the world of Dominator.

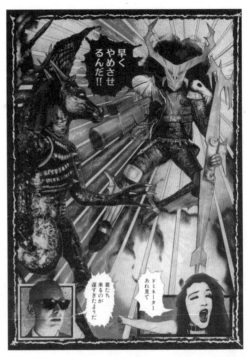

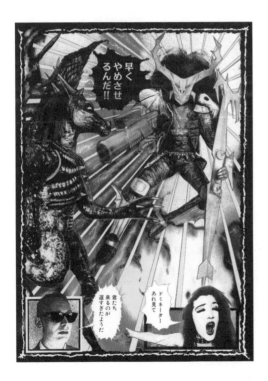

Also notice the slight difference in colour bias between the two images. There's a bias towards yellow in the second one, making the yellow light more intense and bringing out more green in the image overall. **Play around with colour balance** in your imaging or photo app – try different effects until you find the one that works best for the effect you want.

Image 4 - Keeping It Simple

Here I've used a simple split-page arrangement, with the line at a slight angle – angles and slants are always more dynamic than horizontal and vertical lines, and they give a page like this more punch. Once again the characters were photographed, scanned and printed then assembled onto the page. Kodansha's letterer finished the job with some terrific speech balloons.

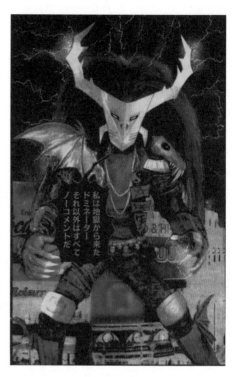

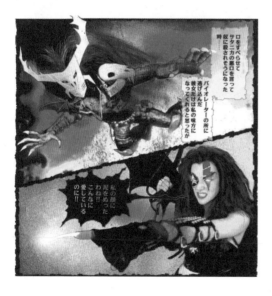

Image 5 - The Paste Pot Strikes Back

This Dominator splash page is a photo of a small animation model, with elements hand drawn onto the photo in paints and markers. The background is a collage of photos, advertising and imagery distorted to the point where it's unrecognisable, coloured and pasted up with the lighting and dark sky drawn by hand. Once again, that wonderful coloured lettering ties it all together.

Image 6 – Model Behaviour

This time I've used a live model, wearing a combination of basic Goth and fetish clothing and clubbing gear. The background, wings and facial paint were added by hand. Nowadays you can do this kind of work in Poser, as I do. If you're lucky enough to have friends who will model for you, you can transform them into heroes, villains and supernatural beings.

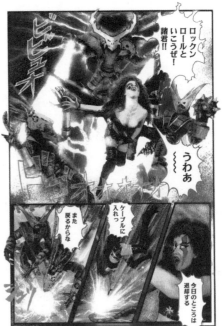

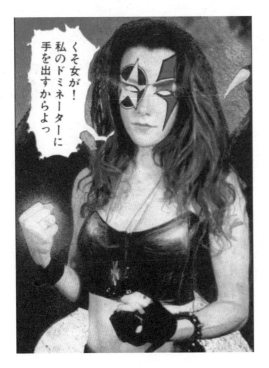

Image 7 – Nothing Succeeds Like Excess

This is a packed page so I deliberately kept the panel layout quite simple. Having the bigger panel with most action at the top of the page works for Japanese and Western audiences alike, and the arrangement of the three figures below Dominator is a classic, originating in ancient art. Keeping the lower **sound effect lettering almost transparent** ensured it didn't form a visual barrier to the action. The three panels below have angled edges, to keep the dynamism

going.

Image 8 – Goodbye old-school

Dominator was great fun to do, but today it would be easier to achieve. Remember, working with collage and traditional materials mean that once the page is complete you can't disassemble it to have a look at how it works! All these pages are as they appeared in *Comic Afternoon*. If I were to do a new *Dominator* comic I could save each layer and show you all the strata of each picture.

Quick Tip:

If you decide to make a project like this, using traditional materials and crafts, you may want to scan or photograph every stage so that you can record exactly how you achieved your effects.

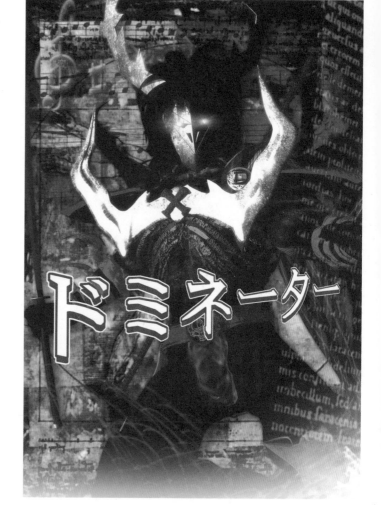

Artist Info: Images © Tony Luke. Website: www.tonyluke.deviantart.com

COMEDY ACTION IN A WEBCOMIC BY TAVISHA WOLFGARTH-SIMONS AND RIKKI SIMONS

In our web comic, *@Tavicat*, our cats Pippi and Fargo get up to all sorts of trouble. The action in these comics needs to be drawn playfully with an emphasis on comical expression that doesn't feel too ridiculous but at the same time stretches the character models slightly outside their norm. Here is one such comic.

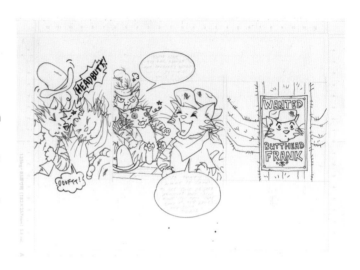

Step 2

With these first two steps, Tavisha has drawn the comic using a non-**photo blue pencil**. This is so she can ink the lines and then scan the image without having to spend time erasing the pencils. The blue will be easier to remove than dark pencil when the comic is scanned. Once the image is in Photoshop, the word balloons are separated by the rest of the comic using colour.

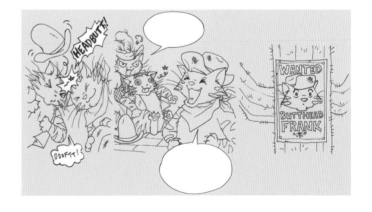

Step 3

Continuing to separate
out the characters and
backgrounds and word
balloons using colour, Rikki
also takes the time in this
stage to draw the panel
boxes in Photoshop using
the **Line tool set to
Pixels**. The panel boxes
are drawn to look jagged in
order to feel more natural.

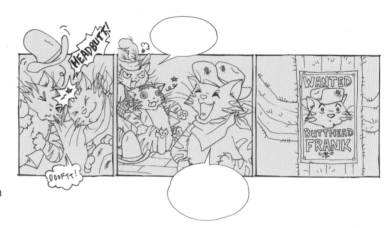

Step 4

The colour style for these
characters are done in a flat
style in Photoshop using
the Pencil tool and the Paint
Bucket with Anti-alias
turned off and Contiguous
turned on. A **pastel colour
pallet** is used to supply a
pleasing open tone to the
panels. Fargo has just had
his head bashed in but he's
okay. He's in pastels!

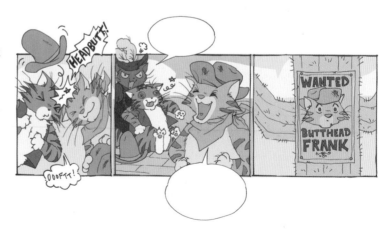

Step 5

Tavisha likes to draw little bits of curly lines around the outside of the characters' faces, very simple stuff, to show the action. This is a classic way to show comical events afoot.

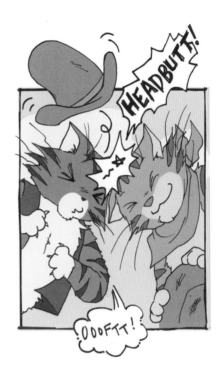

Step 6

And here we have the outcome. Comedies are best when very simple. Our panels are drawn and our colours are set and in go the words. We use the **Text tool** set to **Paragraph** on each separate word balloon. The words are the last step for a web comic and the image is flattened and saved. Here we go! It's Headbutt Frank!

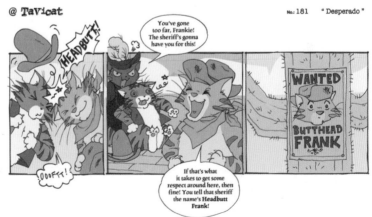

Artist Info: Images © Tavisha Wolfgarth-Simons & Rikki Simons. Website: www.tavicat.com

SAMURAI MANGA - ASCENDING BY INKO

Step 1

After spending a while brainstorming and solidifying ideas, start creating rough scripts, which can be in any form: doodles, texts, or a mix of both. Then create a new comic file on Clip Studio Paint and set the size. You can see some panels come to the edge of the pages in this sketch – as the artist, I knew some edges would be cut off and lose a little detail, but I wanted to use that for effect.

Step 2

Change the sketch layer opacity to 50%; start inking with the **G-pen tool** carefully on a new layer. The image will be entirely B&W, so fill any strong shades with black ink where normally left untouched in colour drawing for later colour shading. Let the **black ink flow freely** without worrying about going beyond the panel borders; the outer panel area will be covered by White later.

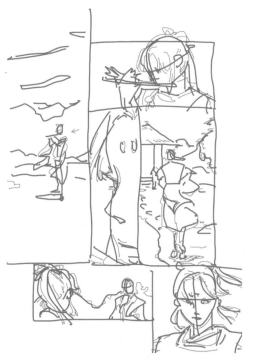
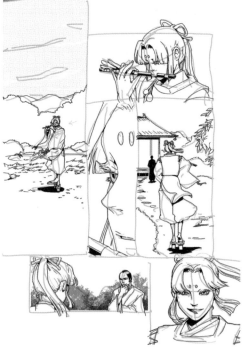

Quick Note: There is no dialogue on these pages, so you can see the detail of the page construction more clearly.

Step 3

Create a panel layer, cut up the panel square with the **Panel Slice tool**, and change the size of panels by using the Object Selecting tool until the page looks as you want it. Now all excess ink lines are hidden underneath the panel layer.

Step 4

Create a new layer and fill all character figures white: use the Magic Wand Selection tool, select background inside a panel, then invert the selection area and finally fill with the **Colour Bucket tool**. Repeat this for every panel. No matter how much background you draw under those layers, it will not affect the foreground character figures.

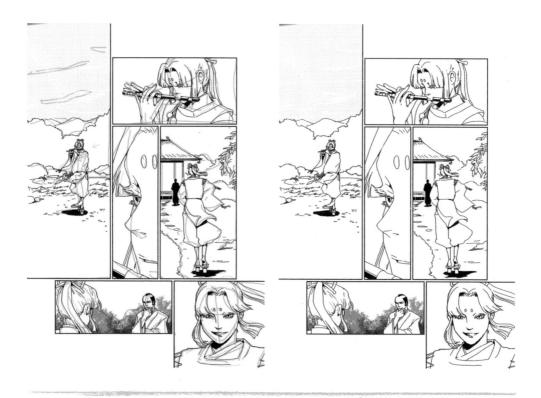

Step 5

The application contains a range of tones you can use for B&W manga creation. You can either select areas to paste tones, or use the Brush or Pen tool to fill areas. You can mix different tones and patterns together, or **add white on a new layer** on top to give an extra texture.

Step 6

More effects can be added on a new layer - musical notes, more clouds, and dancing leaves. To create a harmonious page, regard the whole page as one image, and **balance out dark and bright tones**, rather than thinking about each individual panel separately. The page look and flow are important. Finally, rasterize the Panel layer, and it is done!

Artist Info: Images © Inko. Website: www.Inko-redible.blogspot.com

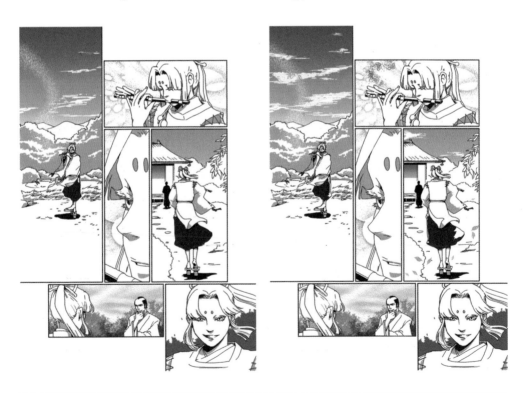

COMEDIC DISTORTION 1 – BAD EGG BY DAN BYRON

Step 1

I start each panel of *Bad Egg* with a rough pencil sketch. In this scene Paulie the Scottish gangster penguin is angry that his car broke down.

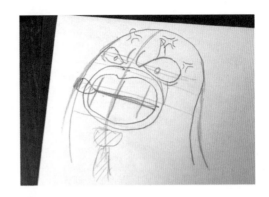

Step 2

Next I'll do a basic inking where I trace and slightly adapt the sketch.

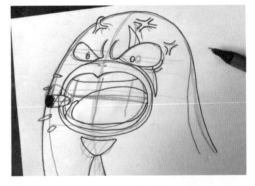

Step 3

I erase the pencil sketch and take my time to fully ink the image.

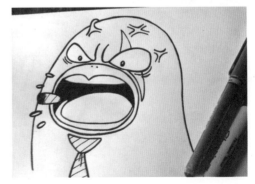

Step 4

After scanning in the artwork, I erase
its background by using the Paint Bucket
and Background Eraser tools. It's the
last panel of the page I'm currently
working on.

Step 5

I only want to use a small part of the
photo I've opened so I use rectangular
marquee to select the area, I'm going to
add a radial blur filter in zoom mode, for
dramatic effect.

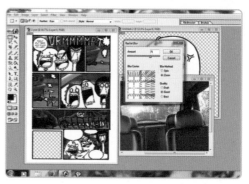

Step 6

After that I drag and drop the image to the
layer behind my artwork. I also flipped the
photo horizontally so it matches the
continuity of the sequence. (Paulie is the
gang's getaway driver).

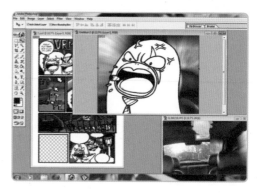

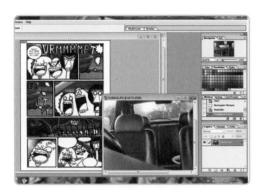

Step 7

Also for the sake of continuity, I decide to add a section of the car's dashboard from the photo and place it on a layer in front of the artwork.

Step 8

Now that's done, I'll add the last speech bubble for the page. I keep several sets that I've made in the past and reuse them. I'm going for the spiky bubble to really get Paulie's rage across.

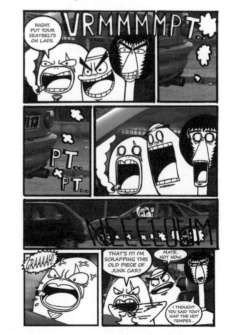

Step 9

Another page finished.

COMEDIC DISTORTION 2 - CROSSOVER COMIC BY TONY LUKE

For the world's first east-west comic character crossover, where Dominator mixes it up with anime star Tsuyoshi (from the manga and TV show *Get A Grip! Tsuyoshi* by Kiyoshi Nagamatsu) in the million-selling pages of Kodansha's anthology *Comic Morning*, I drew the anime characters directly onto **CS10 paper** and coloured them by hand before cut-and-pasting them into the final collaged pages. The results were... different!

Fast-forward to the present day and with **3D apps** like Poser and Daz Studio, there

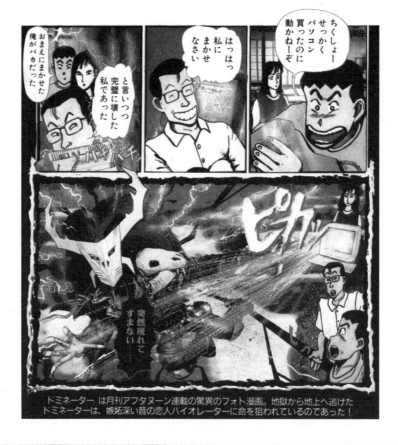

are a wealth of methods available to originate manga-influenced characters and content to use in your own works. Don't be held back by invisible 'manga rules' – just experiment and try different things out until you find your own, unique, voice.

Because both Dominator and Tsuyoshi were popular characters with followings of their own, they both had to look as their fans expected. As you can see, the speech bubbles for the characters from each 'world' are different. Tsuyoshi's creator Kiyoshi Nagamatsu made his

manga starting in 1993 for *Comic Afternoon*, where Dominator also appeared. So they weren't from such different worlds after all!

Quick Tip: Crossover and parody manga are great fun, but remember you shouldn't publish work involving any other creator's characters unless you get their permission first.

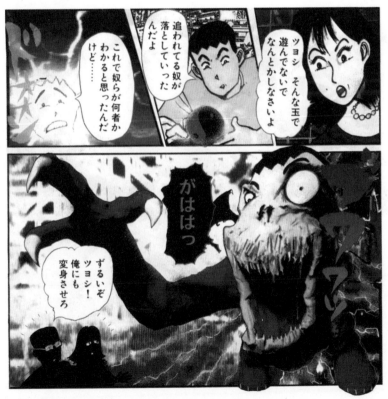

Artist Info: Images © Tony Luke. Website: www.tonyluke.deviantart.com

The Art of Cute

LOLITA FASHION

'Lolita Fashion' is an alternative clothing subculture that focuses on high quality clothing styles, influenced by modest Victorian-style. There are many style types, including 'gothic' and 'mori'. 'Mori' is Japanese for 'Forest', and this earthy 'forest girl' feel often coordinates a fantasy style with a whimsical attitude.

SWEET LOLITA FASHION BY LAURA WATTON-DAVIES

The fashion choices used here encompass cotton, lace, ribbons, hearts and fluffiness. Taking inspiration from many other 'sweet' Lolita fashion styles, this look is pretty cotton-candy-cuddly. A fantasy-reality world of always-around soft toys and constantly-available parfait.

Step 1

This is the very rough pencil sketch idea of the chosen Lolita image. All accessory elements are pencilled onto this sketch and carry through to the final image. The image is neatened and balanced in between this **rough pencil stage** and inking digitally.

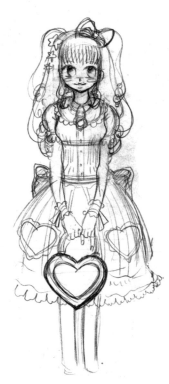

Step 2

Here the silhouette shape of the skirt and
other elements were added, such as shoes
and handbag accessories. Some elements
were removed and less fussy detail added.
This image was printed out using a laserjet
printer, and coloured using alcoholic marker
pens with brush tips.

Step 3

Very light pastel colours were chosen to
complement each other. Quite a lot of
white was left uncoloured, to show through
and work as a very light coloured fabric.
Shade was coloured using greys and purples,
no blacks.

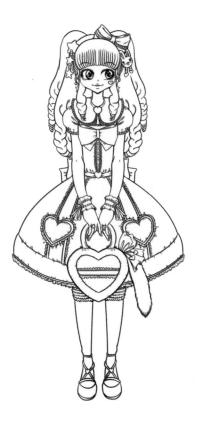

Step 4

Once coloured the image is scanned into a digital format, cleaned up and borders are added using a digital paint program. Background shades should help push the image forward by being relatively plain but bold.

Step 5

Here some white graphics have been added around the character to change the image into a poster design and fill up the layout area. The colours selected match the character's clothing choices and palettes.

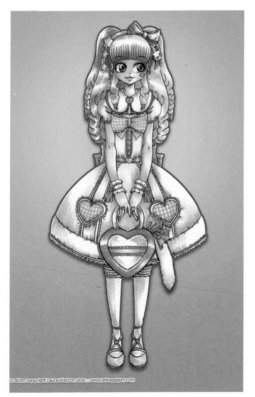

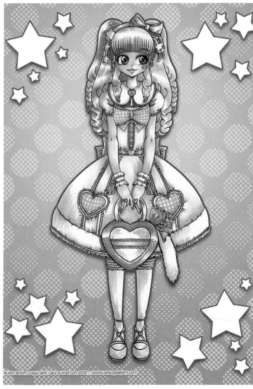

Artist Info: Images © Laura Watton-Davies. Website: www.PinkAppleJam.com

MORI LOLITA BY LAURA WATTON-DAVIES

Step 1

The inks here depict many elements that make this Mori substyle complete. The headpiece incorporates small antler accessories with a fluffy bow and faux woodland roses. Do not be afraid to utilize photos or real-life observations of technical objects to help with accuracy.

Step 2

Colours were added digitally here. If you have difficulty finding an original pattern to use, try out different brushes and see what textured effect they give. Blush pink choices were used here to match earthy browns and warm greys.

Step 3

Light and shade has been added here to give the character a more three-dimensional effect. You can adjust the brightness using level sliders found in the menus of digital paint programs. A soft brush was used to match the look and feel of the nature theme and fashion style.

Step 4

The image was put on a warm brown background, with graphical shapes to frame the character's pose. If you like to take photographs, you could also use one of your own compositions as a background, maybe of a forest scene in the autumn, to match the colour scheme – for either a mixed media effect, or paint over your photograph using the digital paint program.

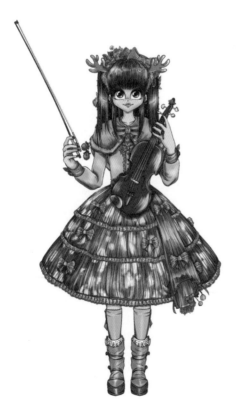

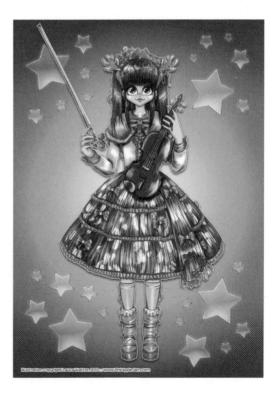

Artist Info: Images © Laura Watton-Davies. Website: www.PinkAppleJam.com

PURPLE GOTHIC LOLITA BY LAURA WATTON-DAVIES

Gothic Lolita can pull in all sorts of elements, and this character's take on the Gothic Lolita fashion style incorporates backpack wings and some horns, as well as many silk ribbons and tiny bat motifs. The hairstyle is long and in a dip-dye style. All colours blend in well with each other, with a cartoonish and cheeky feel to the style used here.

Step 1

Everything here started with a very rough sketch idea. When drawing, I realized I wanted everything to be symmetrical. I didn't worry about getting the pencil lines down exactly parallel; I edited this in a digital program in between this stage and the next stage.

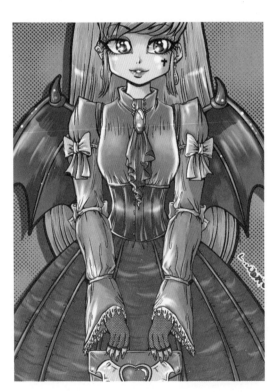

Step 2

After getting items like bat wings and skirt shapes exactly balanced (usually by cutting out one area digitally, flipping it horizontally and placing in the appropriate place) I inked over the rough pencil lines to give a smooth, balanced inked version of the figure. The intricate lace gloves were toned using a **digital dot pattern**.

Step 3

Here the character was painted in a digital paint program and some smooth highlights were painted on top using a **soft digital brush**. The palette chosen is cute but dark, without resorting to black shades everywhere.

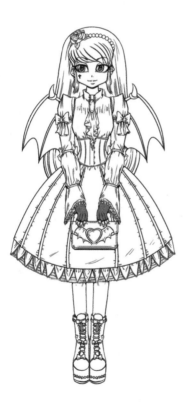

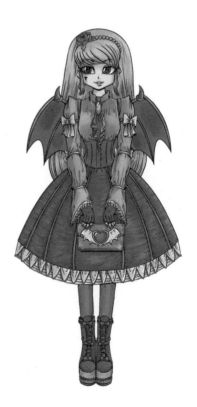

Quick Tip: You can use flipping to create an exact mirror image and make sure parts of a drawing are symmetrical.

Step 4

Some additional shade was added on a completely separate layer. I could adjust the darkness using a **colour balance slider**. It's always worth checking out more detailed tutorials to get different effects using different tools and slider options.

Step 5

Highlights were added using a soft paintbrush to give the character more dimension. The layer format was changed using the drop-down menu options to emphasize luminosity. The **light source** shines onto the character from both bottom left and bottom right areas of the picture.

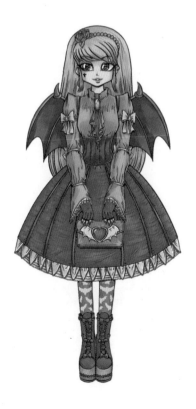

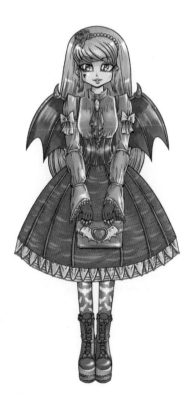

Step 6

Extra graphical elements were added to frame the character. The character poster you make can be printed out as posters or cards to give to friends and family if you like.

Step 7

Extra ideas for graphic design layouts – this is a layout for some hand-crafted jewellery. Items are places on the card (in the gap on the right), bagged in a cellophane wrapper and sold at craft fayres and conventions. Adopt a similar layout if you also make small items you wish to sell to make your product look awesome in super cute packaging!

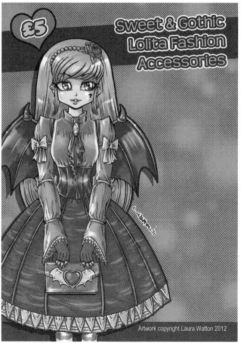

Artwork copyright Laura Watton 2012

Artist Info: Images © Laura Watton-Davies. Website: www.PinkAppleJam.com

BLUE GOTHIC LOLITA BY LAURA WATTON-DAVIES

Step 1

The most important part of an illustration is getting the silhouette right – flip your drawing back and forth to see if it balances out correctly too. Be very messy at this rough stage, because looseness helps generate an energy and movement in a drawing.

Step 2

Ink over the pencil sketch with your preferred inking method. You can add to your shapes when inking – at a pencil stage there is no reason to always draw every detail. It can speed up the process if you rough out a shape and go into more detail when inking.

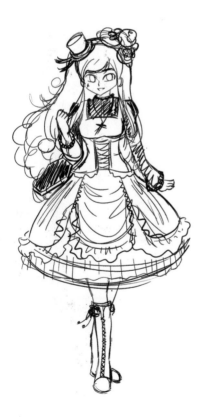

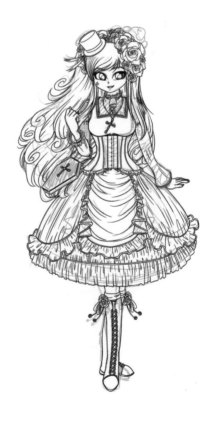

Step 3

Finished digital inks. Remember if you ink manually, use a lightbox or a quality of paper that complements your linemaking. This picture is inked digitally which allows lines to be 'undone' if they don't look right. Always ink on a separate layer.

Step 4

The digital ink work can be printed using a laserjet printer if you fancy a change from staring at a computer screen for the next stage. Using alcohol-based brush tip markers, colour in your character. Leaving bits of paper underneath white to create a highlight effect. Start colouring using the lightest colours first.

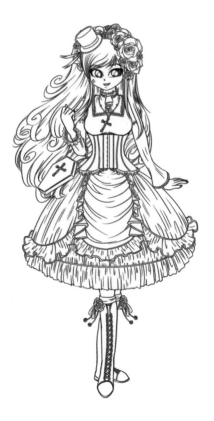

Step 5

When colours are added, scanning in your piece allows for a quick tidy up and adjusting of **lightness and darkness levels** to get better brightness balance. Using a digital paint program of your choice, adding highlights is easily done to give a little more dimension.

Step 6

Place the character on a top layer and digital graphics can be added to the background to match the look and feel of your character type. If the background is busy you can add a border around the character to lift them out of the design. **You can make cards, posters and prints** from your finished character.

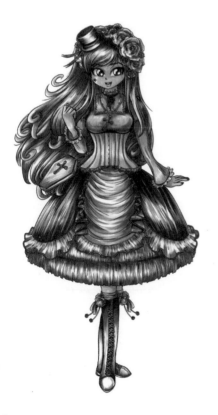

Artist Info: Images © Laura Watton-Davies. Website: www.PinkAppleJam.com

MINT SWEET LOLITA BY LAURA WATTON-DAVIES

Step 1

The layout pencil stage should be fast and loose, with shapes depicting where things should go. Pattern detail can be added at the next stage, but a rough line should be enough to depict what looks best. And if you don't like it, just rub it out!

Step 2

Ink over the pencil sketch, either on a new layer if you are using a digital inking program, or on a fresh piece of paper if using **fineliners or dip pen**. You can trace over your pencil sketch if inking manually.

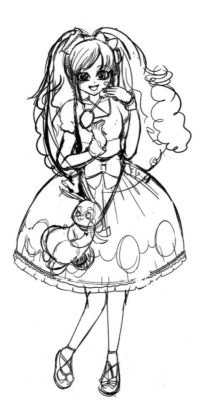

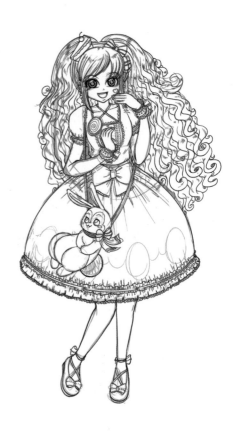

Step 3

The finished inks. As this picture was inked digitally, **extra patterns** were utilized on the cap sleeves and the base of the dress. The bell-shape of the bottom part of the dress is structured via a petticoat underneath so the outside lines should be smooth and rounded. If the character is wearing matching accessories, make sure details are parallel on each one.

Step 4

The digital inks were printed using a laserjet printer and alcohol-based brush tipped markers were used to apply colour. Using lightest colour shades first, colour is applied, building up layers for darker strokes. Leave **white areas of the paper** for the brightest areas.

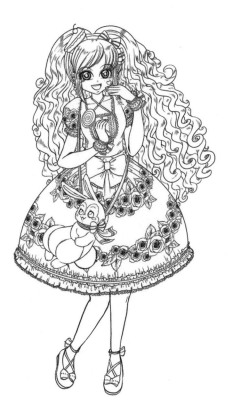

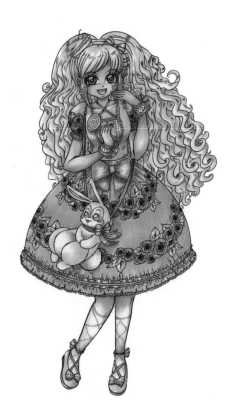

Quick Tip: Invest in a lightbox so you don't have to rub out pencil lines if you ink onto paper on top.

Step 5

Scan the coloured picture into the digital program and tidy using the Brush and Eraser tools. You can add highlights on a new layer if you like. Always **draw on separate layers**, because mistakes are far easier to edit this way. Reduce opacity in case the additions are too bright.

Step 6

The final edited picture is placed onto a colourful background. Adding graphical shapes complement the playful pose. Simple shapes don't detract from the detail found on the character herself and when added to separate layers they can be arranged to find the best layout. Your final character can be printed onto posters and cards. You can make a whole set!

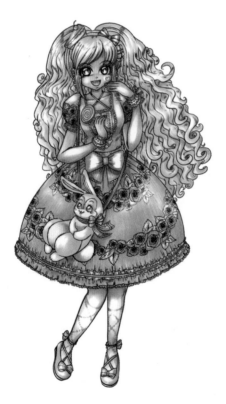

Artist Info: Images © Laura Watton-Davies. Website: www.PinkAppleJam.com

CUTE CHARACTERS & SETTINGS

Cute characters have become very popular outside manga, in advertising and fashion illustration. This includes chibi (child-bodied) characters and animals. In cute manga, the lines and shapes are generally soft, flowing and rounded and the colours are usually warm, soft and gentle.

POP FAIRY NECTARINE BY LAURA WATTON-DAVIES

Step 1

This is a chibi character. The idea started as a pencil sketch, using coloured pencils and fineliners, with white paint for highlights. The original drawing was pretty cute – but can it get any cuter?

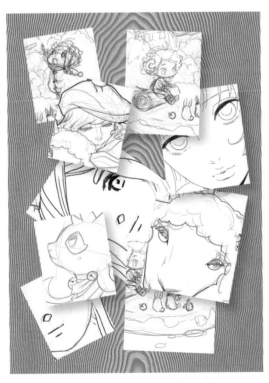

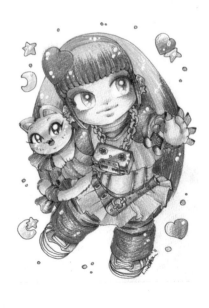

Step 2

The character was redrawn in a digital painting program with a super soft brush. This gave a smooth quality to the line. Proportions were changed but the concept remained the same. Many lines were erased before settling on the final look and proportion.

Step 3

Using a scan of the original pencil drawing, the shades were colour picked and redrawn underneath the new digital lines. Some detail that seemed too much was erased, and other details remained in the final piece.

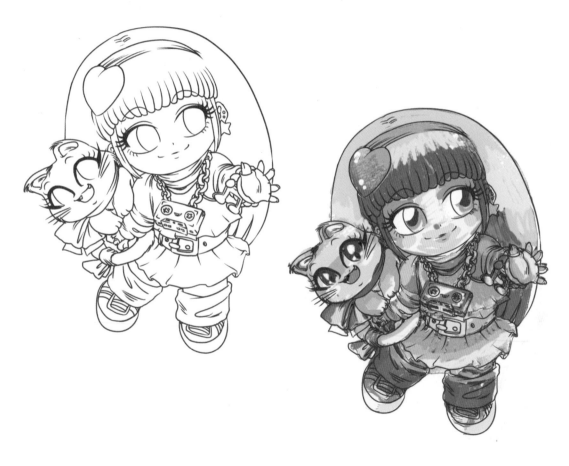

Step 4

Once the colours were decided upon, the edges were cleaned up and areas neatened. The smooth painting program also had different opacity features in the brushes, so adjust and experiment to find the right effect that suits you.

Step 5

Finally, on a separate layer, the last stage is to utilize the different luminosity effects that the painting program had to offer. Adding some highlights and shine compliments the cuteness of the character.

Think about where you can use your character – as gift tags, make greetings cards, or print out on acrylic to make jewellery or charms. The digital world has so many possibilities for your work; take a look around at outlets online that can help transfer your work onto some great products.

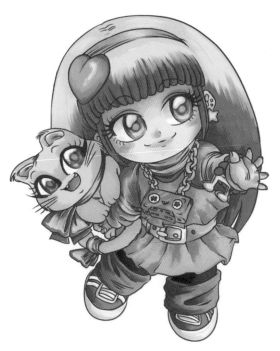

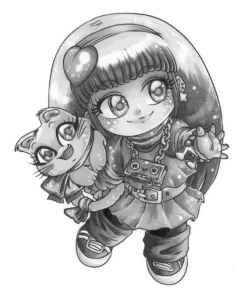

Artist Info: Images © Laura Watton-Davies. Website: www.PinkAppleJam.com

WINTER COLOUR BY INKO

Step 1

Sketch out lovely winter cheer using the **Thick Pencil tool in Blue** on Clip Studio Paint. You can edit and adjust the size of characters in any way, so feel free to add anything. I suggest a girl, a sheep, and a robin...

Step 2

Once you've decided on the characters in the foreground, start inking with the textured Pen tool in Brown on a new layer. In this illustration a background will be drawn too, but to make foreground characters stand out from the whole image, they are the only figures to be inked. Make the **outline of the front figures thicker** than other lines. You can see how carefully chosen those simple lines are.

Step 3

Now leave the background and sketch line aside, and start colouring the characters with the **Colour Bucket tool** on a new layer. Just fill the colours section by section, which is easy! Warm colours were applied at this stage, but just wait, you will see colder snow colours later.

Step 4

Tada! 3D effects are added on a new layer using the **Thick Watercolour Brush** and **Non-translucent Watercolour Brush** to give a hint of light, shade, pattern, and a touch of Pink. The lighting is from underneath, so that gives an extra touch of a pink shade on top of the girl's nose.

Step 5

Finally winter chill started crawling into the picture! On a new layer, use the same brushes, but add deeper colours for stronger shade effects. Light Blue and Light Purple are also added for a reflection of light bouncing off the snow.

Step 6

A beautiful winter sky on a curvy horizon is here! Fill a new layer with dark navy, and make this the bottom of all your layers. Create another layer and use the **Haze tool** in very light Blue, very light Yellow, and very light Pink, to start adding cloud in faint rainbow colours. Select various twinkle Effect tools, which Clip Studio Paint can offer you to depict shiny icy air.

Step 7

Set a new layer as **Overlay**, then add bright Pink with the **Airbrush tool**, by giving thicker colour on the girl's skin and the sheep's ears. Now they look like they are embraced by a natural pink glow.

Step 8

Duplicate the ink layer and give a **Gaussian Blur filter for 18%** to make ink lines softer. Create new layers and set them as Add (Outer Glow). Place one between background layers and foreground layers, and another on the very top. Add white glow on the tips of eyelashes, eyes, hair and fur; airbrush at the bottom right corner of the image; and finally draw shiny trees. Enjoy decorating it with the Snowflake tool and Star tool. Then your winter image is done!

Artist Info: Images © Inko. Website: www.Inko-redible.blogspot.com

CHIBI SNOWDOME BY CHIE KUTSUWADA

Step 1

Here is how I draw a chibi. This time, the theme is a snow dome/self-contained small world, so check the balance of the characters and the background, and start thinking about what the best way to make the characters look cuter is. Firstly, make a rough idea drawing. The program used here is **Clip Studio Paint**.

Step 2

Make a new layer for the rough drawing 2. Concentrate on the detail, especially the body balance of the chibi character. Simplify the eyes and make the position of them lower than usual. Forget about the nose. If the chibi's face is too busy, they do not look that cute. Do not forget the neck and do not make them unnecessarily chubby unless you are drawing a chubby character.

Step 3

Finalize the roughs for the chibis. Even though the chibi is quite a simplified drawing, their costume should look functional. Think about or refer to actual small dolls' clothes. They are tiny but wearable.

Quick Tip:

If you don't have a project in mind, you can monetize original drawings like this by offering them as greetings cards, posters, mugs, phone cases and more using online merchants.

Step 4

Create a new layer and start inking. For chibi drawing, I use a very even, less pressure sensitive pen. My ideal chibi looks quite pop and stylized. **Evenly drawn crisp lines** will help to realize those qualities. Check every section is closed in order to use the Paint Bucket tool later to colour them without any stress.

Step 5

Ink the animals on a separate layer. I simplified them to match the chibi characters. However, you need to know what those animals look like if you want to draw them in a simplified style. My advice is, look at references. Check out the details such as each animal's distinctive body balance and face shape etc.

Step 6

Create a new layer and start colouring. I usually start with the faces. I simply use the Paint Bucket tool to do **block colouring** and the quite simple shadows on hair and horns, because their hair has certain volume. Personally I prefer soft milky colours for hairs and skins. Using sharp vivid colours too much, especially on faces and hairs, are sometimes too strong so the image might look less cute. I tend to use colours that look edible, like cupcake icing colours, to obtain a natural feel.

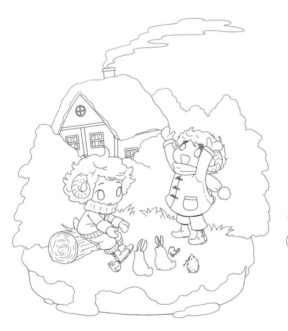

Step 7

Make two new layers, one for the clothes and one for the animals. Here I recommend **using some references** again. I regularly check fashion magazines/websites to look for cute co-ordinates or trendy colour schemes. What your character wears reflects who they are and what kind of person they are. So take time to think about it. Also, in order to colour the animals, I referred to real animals' colouring, so they became a bit more believable.

Step 8

Colour the background on a new layer. Keep it simple so as not to distract from the characters. For the shadow of the snow, I use slightly red-purplish-grey to make the whole image not too cool. Even in a simple drawing like this, if you give some shadows to the characters, they look more solid on the ground. Giving shadow is important so use it well.

Step 9

Enhance the outline to bind the objects together. Add some highlights on the characters eyes, cheeks and hair. Do it on a new layer so you can try to put the highlights on different positions in order to search for the best position. Take your time, especially for highlights for the eyes. They are so important to make your characters alive and energetic. Finish up with adding some snowflakes and sparkles.

Artist Info: Images © Chie Kutsuwada. Website: www.chitan-garden.clogspot.com

CUTE AND FURRY BY SUMMER CRUZ

Step 1

For this picture, I'm going with a bust, to focus more on the face of my character. I used **Manga Studio 5** for this project. I've outlined the basic shapes in red and made a rough sketch of what I want.

Step 2

A second go-over with the canvas flipped in the opposite direction (to catch anatomy errors) and I've got a sketch I'm satisfied with.

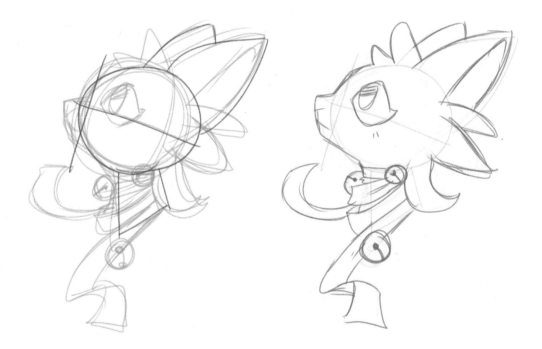

Quick Tip: Flip the image digitally in on a lightbox or windowpane to check the drawing.

Step 3

I drop the opacity of the sketch layer and
start on the line art. I want something a
little more delicate, so I'm using a **smaller
brush (set to 5)** to get a thinner and more
elegant line.

Step 4

Fill in those colours! Remember – selecting
inside the lines on the line art layer, and then
dropping the needed colour in the layer
below it with the **Fill/Bucket tool**, will save
you a lot of time.

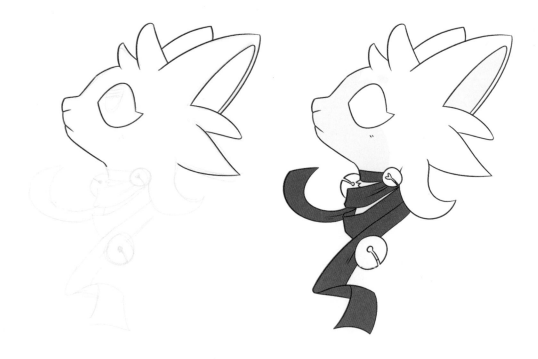

Step 5

All the colours are in, and the line art looks great.

Step 6

On a layer above my colours, I lay down some basic light and dark colours liberally and add some sparkle to the eyes. Once I've got it the way I want it, I drop the opacity so the colours **fade and blend** in with the ones underneath.

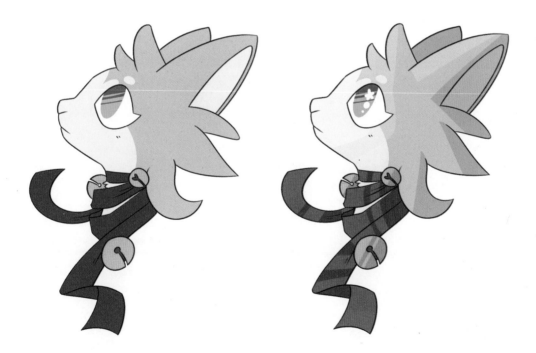

Heavy Metal

METAL SHIPS

Drawing mecha requires patience, precision and careful observation. You might not think it, but observing cars in a car park can help you a lot in creating a mighty battle fleet.

SENKAN
BY NEWTON EWELL

Step 1

I've made a rough sketch of a battleship – *senkan* in Japanese – but it needs cleaning up in Illustrator and Photoshop before we can start to paint it. First scan the rough sketch into the computer. Rough drawings can accelerate the creative process – the rough, 'dirty' line work can inspire even more creativity when you see it onscreen in Photoshop.

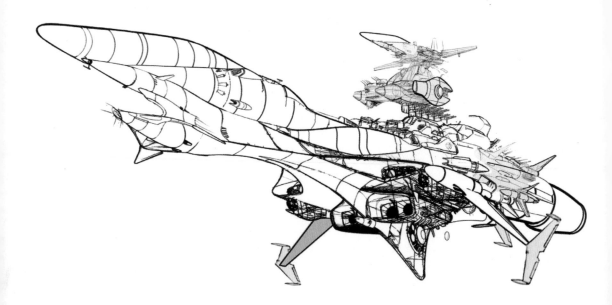

Step 2

Flip your drawing (using Image/Rotate Canvas/Flip Horizontal) to check for flaws in the drawing. Overall balance, missing parts, even radical changes to the initial design become easier to see and **correct in Photoshop**. This is especially important on a three-quarters view. It's easy to miss little details like misalignment of structural elements.

Step 3

I noticed a perspective issue the moment I flipped the drawing. The spaceship's stern and nose were misaligned, making the design look awkward. I had to line up the stern with the nose.

First, isolate the stern on its own layer. I place my cursor on the Background layer. Right-click the mouse, opening up a Layer Control Panel. Choose '**Make Layer From Background**' and click. The background becomes Layer 0, indicating that the background is now 'floating' like all the other layers.

This means that your background can be changed by your tools, so in the Layers window just above the topmost layer, click the little Lock symbol (making sure you select the right layer). Now, your new layer is saved in case of accidents.

Step 4

Unlock the layer again and **duplicate** it so
that you have two spaceships, each on its
own layer. Cut away the stern on the
upper level and keep just the stern on the
lower level. Once the layer is unlocked,
right-click on it, select 'Duplicate Layer'
and click. Take the time to click on Layer 0
and re-name it Nose (or Main Ship is you
prefer.) Click on your duplicate layer, and
name it Stern.

Step 5

In the end, you have an upper layer
containing the main body of the ship, and a
lower layer which contains the ship's stern.
In your Layers palette, click on the Stern
layer. Click the Move tool, and then slide the
stern layer into place using both the Move
tool and **Edit-Free Transform** to bring the
stern into perspective with the main body
of the ship.

Step 6

This has improved the drawing immensely.
Now apply the finishing touches:
Clean up any missing line work using the

Pen tool to create sections that can be **filled using the Paintbrush**. You have now successfully done clean up on a line drawing. You're ready to start painting.

Step 7

Notice how there's more detail on the finished picture than on the first rough sketch? All those extra armaments and parts were **added in Adobe Illustrator**. It lets you make crisp, clean drawings regardless of their original condition. Tools called **Bezier curves** and **handles** allow you to trace and manipulate line drawings from your roughest sketch.

Step 8

I started by importing the rough sketch of the bridge into Illustrator as a .jpeg image – Illustrator works best with **jpegs for tracing**. I turn the layer containing the sketch into a template, which 'locks' the layer in place, and lightens the line work by about 50%. This creates an easy-to-see, untouchable base from which to trace.

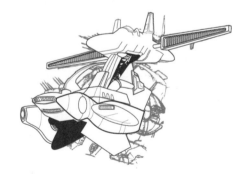

Quick Tip: Make sure you can easily see both layers by removing excess white space with the Magic Wand and the Delete key.

Step 9

Using Illustrator's controls for line width, and the Bezier handles, I create a clean tracing of the parts I wish to add to my spaceship drawing. When you **import an Illustrator drawing into Photoshop**, you can scale it up as large you please, without the detail breaking down into jagged pixels – great for big, complex mecha drawings.

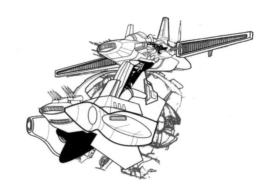

Step 10

By bringing in an entire part, say a bridge or gun tower, you can check the object's size relative to the entire drawing, and adjust the piece to fit quickly and easily. I created cannons of various sizes and placed them on my ship to create a dreadnought of the skies.

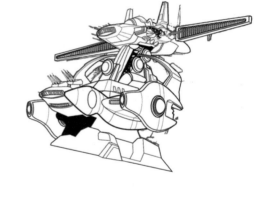

The final picture layers are **merged down to the ship level**, and I handled cleanup with Photoshop's impressive array of tools. Teaming Photoshop with Illustrator means there's nothing you cannot draw!

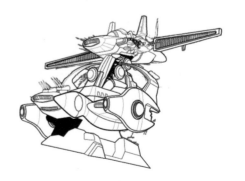

Artist Info: Images © Newton Ewell. Website: www.newtonewell.com

FIGHTER BY NEWTON EWELL

Step 1

Make sure your drawing is crisp and easy
to scan. This can be done traditionally with
pencil or pen, or digitally. I like to play –
to let the project guide me. In this instance,
I decided to try an **all-digital rendering**.
I began with a rough sketch, scanned and
imported to Adobe Illustrator for
refining and cleanup.

Step 2

In the first layer, I lay down the fighter's
base colour (R211; G212; B230). I use
the **Dodge** (Midtones; 100% exposure;
Airbrush On) and **Burn** (Range: Midtones;
50% exposure; Airbrush On). Once I'm
satisfied with the overall look, it's on to
a new layer.

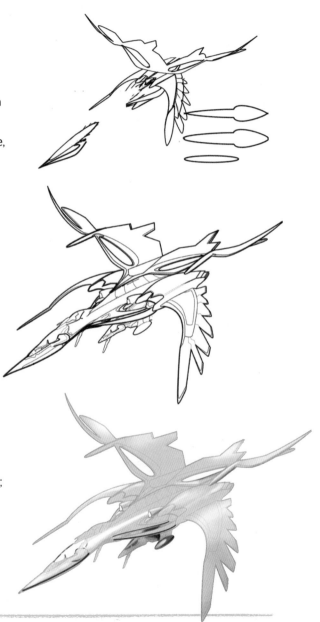

Step 3

I want this machine to have a pearlescent look. Using the Pen tool, I lasso a portion of Layer 1, then Copy it into a new layer. Next, I create a gradient of blue-violet (R46; G48; B146), white, and orange (R251; G175; B93). This gradient is made up of the complementary colours of the original bluish layer. I use a **Gradient Fill** to flood the new layer with the resulting gradient. I set it to **Multiply**, and adjust the Opacity to 12%.

Step 4

The next layers were made with the **Pen tool, set to Shape Layers**. I picked out shapes to describe complex patterns of light and shadow, and adjusted them with Bezier levers. In this way I build the shadow areas with fine control. With each new layer, I experiment with its **Blending Mode (linear dodge, liner burn**, etc.) and find what works best with each layer to achieve the desired result.

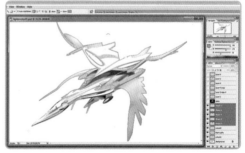

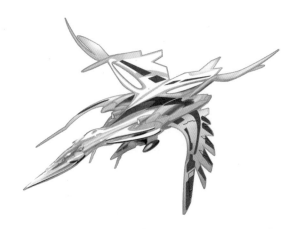

Step 5

(*See* right). The remaining layers consist of imported textures made with **Bryce 5.5** and 'decals' made in **Illustrator**.

Step 6

(*See* below). The 'plates' on the fuselage and wings were also drawn in Illustrator in black.

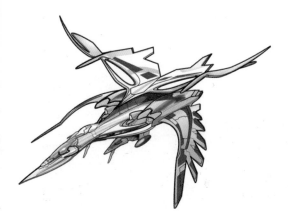

Step 7

Once the lines were in place, I duplicated
and inverted the layer from black to white.
I moved the white layer beneath the black
one, then gently slid the white layer out
(**using the Arrow keys**) to form highlights
that etch out the individual plate lines.

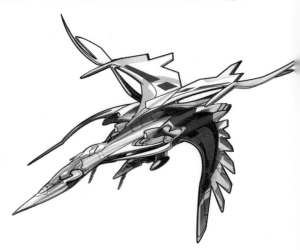

Step 8

I used a detail from another piece I made,
and placed it in a new document. I then
selected the entire background (Ctrl+A)
and filtered it with **Motion Blur**. I re-opened
my fighter duplicate, and cut it out of its
background using the Magic Wand and
Invert Selection (Ctrl+Shift+I). On the Edit
menu, I select Copy. My image (fighter
only) is ready to take the stage. Returning
to my Background document, I select Edit-
Paste to set the fighter in its own layer.
Adjust position with the Move tool, then
flatten the image. Behold – a deep-space
fighter, travelling at hyper-speed!

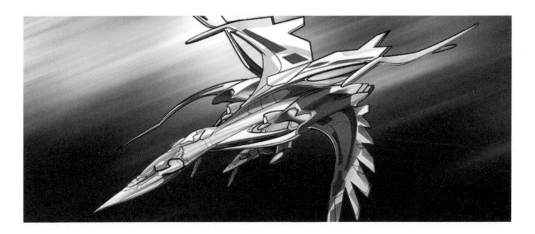

Artist Info: Images © Newton Ewell. Website: www.newtonewell.com

BIOMECHANICS

Create convincingly detailed mecha and armour and mix with them with men and beasts alike to create amazing manga artworks.

REGULUS
BY NEWTON EWELL

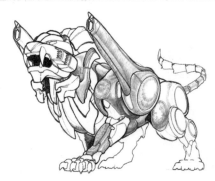

This piece explores the power of colours layered individually, then mixed by regulating the transparencies of each. I started with **basic linework**, inked then shaded with pencil. I was testing out a shading tutorial by Keith Thompson in his excellent book *50 Robots to Draw and Paint*.

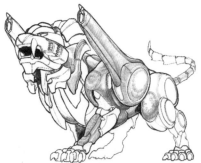

Step 1

I started with the gentle crosshatching he recommends, then began applying colours. The first layer is a medium warm grey, **opacity** taken down to 70% (see image bottom right). This provides me with a semi-transparent base.

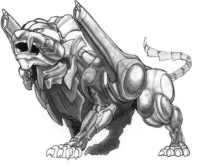

Step 2

I followed this initial layer with a new one: I copied the grey Layer 1, to create the second layer.

Using Hue, Saturation and Brightness (Image/Adjustments/Hue and Saturation; or Ctrl+U) I changed the new layer to a light brown. I reduced the layer Opacity to 40%.

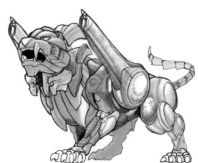

Step 3

At this point, I needed to cool down the piece. The light brown works for me, but I need to retain the metallic edge. I created a third layer using Duplicate Layer and filled it with a light blue.

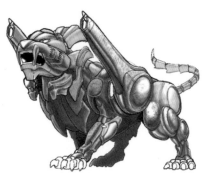

Using the **Dodge and Burn tools**, I then modelled this surface from flat colour to a three-dimensional shape. With this layer, I begin to define my shadow patterns as well as light reflected from the ground. I ultimately decide to save this layer at 40% opacity.

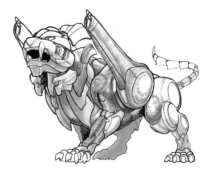

Step 4

Now for the fun part! I didn't want to paint the mecha in realistic lion colours. A quick trip through a **modellers' reference** book on Second World War aircraft provided a cool paint scheme from a German fighter-bomber. To reproduce this paint job, I copied the colour swatches in the book.

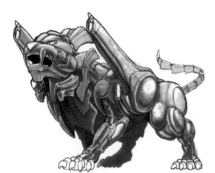

Step 5

I happily airbrushed my colour scheme onto the final layer. This time, instead of adjusting the layer's transparency I decided to set this final layer to **Multiply**, the better to catch all the little colour variations created by transparent layering. The end result is cool, but there's just one more thing missing – highlights, reflections from parts of the machine exposed to a light source.

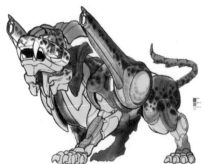

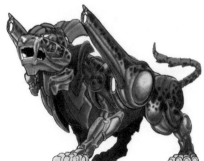

Quick Tip:
Modellers' manuals, reference books, kit instruction leaflets can all provide inspiration and source materials to adapt. Even cards with paint colour swatches given away by DIY stores can be scanned, sampled and adapted.

Step 6

Highlights are the result of reflections from parts of the machine that are most directly exposed to the light source. I wanted to simulate flat-painted surfaces, so one layer of highlights would suffice. I used the light-green colour from the paint swatches, and this time set my **Paintbrush** to **Screen mode, Airbrush On**. Screen allows you to paint with light, gently building up highlights with each stroke. In this way I modelled my highlights directly on the machine. The registry numbers were made in Illustrator, imported into Photoshop and placed using both Free Transform and the Warp tool.

Step 7

Using bright colours on a layer called 'Blackground' (R0; G0; B0) in **Screen mode**, I painted in the eyes and sensors, and show the blaster cannons charging. By switching the transparency of the Blackground layer as I work, I can easily grab just the areas I need to work on and check how they look against the existing finished layers at each stage. When I'm happy, I save them on a single layer and make Blackground 100% transparent.

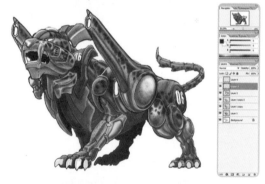

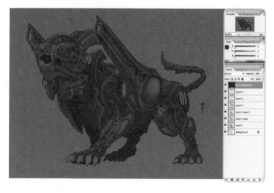

Artist Info: Images © Newton Ewell. Website: www.newtonewell.com

I can also save Blackground in its own document in case I want to reuse the same effects in another project.

Step 8

Using **Colour Dodge** over two passes of orange I create a blinding yellow glow and add tiny dots with the airbrush to suggest energy particles. The same process gives a blue glow to the cannon reactor and a delicate touch of violet-blue to the forward sensors at the side of the head. With these two I add some reflected light to the mech's surface, using the Pen tool and then defining the exact shape I want with the Bezier handles. These small areas of light add huge impact to the finished piece.

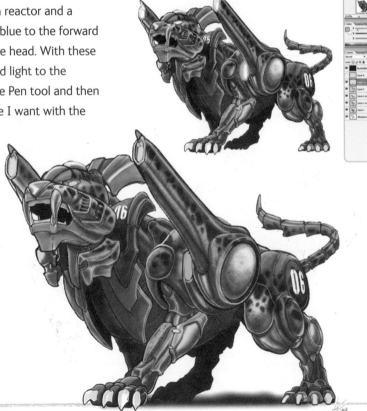

SKRAG BY NEWTON EWELL

Step 1

Lighting a figure takes practice. This punk and his backpack-magazine fed minigun started out in **Poser** (now **DAZ 3D**). I set up the character and adjusted his face shape and expression, and used the model shot as a guide to create my line drawing. The Mohawk was added by hand. I scanned the drawing into Photoshop to finish the line work.

Step 2

Then I added textures, bullet dents, burn marks, and graffiti in Photoshop, tattoos made in Illustrator, and merged all the layers onto a blank background. I needed a background for Skrag and experimented with a number of choices, but I wasn't happy with any of them.

Quick Tip:

Look at photo reference for the poses and accessories you want to create, to get the proportions right and inspire your own work. Using reference material isn't 'cheating' – it's a smart way to work faster and improve your art.

Step 3

In the end I made a simple gradient from white at the bottom to dark grey and set it as my Background layer. A subtle background can work really well, especially for a detail-heavy image.

Step 4

Here's Skrag, proud and strong against his gradient background. Achievement unlocked! Now onto the next step – shadows! I want to make him more three-dimensional. How do I do this? By pushing the shadowed areas back into the drawing. Stick with me here...

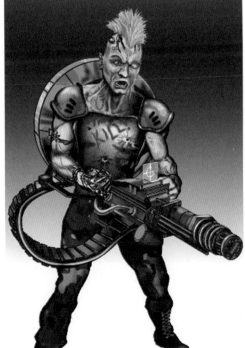

Step 5

First I copy the layer my painting is on. I lower the new layer's brightness and contrast to zero (Image/Adjustments/Brightness and Contrast). I just created a dark grey silhouette – but for what purpose? The **silhouette layer** provides me with a quick and easy way to select either the background or the figure with the Magic Wand tool. This is a real time-saver.

Quick Tip:
There are a lot of 'right ways' to do this little trick – what I've just explained was just my chosen method for that day. Try out different methods to see what works for you.

Step 6

Using the silhouette layer as a template, I grab the negative space around Skrag with Magic Wand. I then create a new Layer, set it to Multiply, and use Select/Invert Selection to isolate Skrag's body area for painting. I pick a dark brown for my shading colour, and darken the areas I want in shadow.

With my **Eraser tool set at 50%**, I gently remove the shadows as well as defining them. Basically, it's using the Eraser to sculpt the shadows. My end result: is he a punk killer or a chimney sweep? Only his mother knows for sure... He looks awfully dirty, but trust me – the cool part starts NOW.

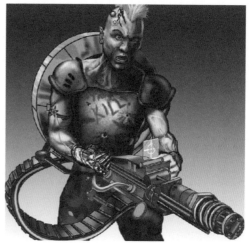

Step 7

With my Selection still in place, I create another new layer. I set it to **Lighten**, and name it 'Greenlite' (proper spelling is optional when I'm working for myself). I then select a light teal green, and go to work. I begin picking out the highlights, as if Skrag is bathed in a greenish light source somewhere off to the right. The shaded layer below makes picking out alternative light sources easy! Starting on the right side of the painting (the left side of his face), gently building up the most intensely lit areas, I use the Eraser tool to carefully sculpt them into reflections on his face and body. It looks okay, but there's more work to do yet...

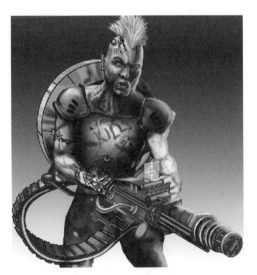

Step 8

Next, I create a new layer marked 'Hilite01'. I set this layer to **Colour Dodge** – I want my brightest brights. Using the same teal-green, this time set to Colour Dodge, I paint in the brightest areas. To make then even brighter, I duplicate my Hilite layer, renaming it 'Hilite02'. OK, now it's bright enough! Once again, I use my Eraser to begin sculpting these brightest brights to fit in with the rest of the painting.

Now I duplicate the painting (Image/ Duplicate), rename it, and then flatten the duplicate image. In SF and fantasy art, you never know when you can reuse an element in another painting. Once I've saved my duplicate image for future reuse, I save my original painting, layers intact. I learned to save artwork from my work in videogames: there's always a reason to r**euse elements**, or make major changes to the original painting. Better safe than sorry is the digital artists' motto!

Artist Info: Images © Newton Ewell. Website: www.newtonewell.com

BASILISK BY NEWTON EWELL

Step 1

This is one of my biomechanical terrors – the Basilisk. Basically an organic tank, Basilisks are set loose on the battlefield to lay waste to their enemies (or victims) with their single main plasma-blaster, also known as 'The Eye of Doom'. I'll use this project to show you some complex colouring tricks.

First, I scanned my pencil drawing. This piece was done on a large sheet of paper, so I had to scan it in two pieces. Using Photoshop's **Photomerge** (File/Automate/Photomerge) function, I reassembled the drawing on my computer. As you can see it's a pretty detailed drawing, and I wasn't sure exactly what I wanted to do with parts of it. After merging it, I used a **Blur filter** (Filter/Blur) to slightly soften the image.

Step 2

I also checked the image for overall balance, which led me to enlarge the biomech's feet. **A little Free Transform** (Ctrl+T), Cut (Ctrl+X) and Paste (Ctrl+V), and the enlarged feet are ready for action.

Step 3

I copied my new parts, and pasted them into my drawing. Finally I was ready for business.

Always scan at twice the resolution you plan to use for your final artwork. If you need to work at 300 pixels per inch (ppi), scan it at 600. This gives you more detail and control.

Step 4

The easiest thing to do is to create an underpainting, either in monochrome, or with at most two or three colours. This lets you work out the darkest darks, and lightest lights. It's easier to see and create the shadow patterns. It gives you the control over your drawing that is so important when doing colour work.

As you can see, I also tried some slight variations in the Basilisk's equipment.

There's plenty of room for experimentation – just don't get caught up in it; I took a long time redesigning my little friend several times! I created my underpainting on several layers to give me absolute control over the shadow values. I've only included a shot of the finished underpainting but I did lots of dithering about exactly how it looked. Finally, I adjusted the **Hue** of my underpainting to a dark brown. Adjusting the hue makes for less work covering black lines later, and adds an interesting feel.

Step 5

Choosing colours, I decided to try something new. I found reference photographs of carnival glass online. Carnival glass is treated to create an iridescent full-spectrum coating, including all colours of the spectrum. I imported bits and pieces from photos that I liked, then blurred and adjusted the colour saturation (**Image/ Adjustments/Hue & Saturatio**n; or **Ctrl+U**) until I got the effects I wanted.

I set my colours on their own Layer. I already had my shadow values solved, which made colouring easier. I kept my colour construct on its own layer to make adjustment easier.

I paint my colours in transparent and semi-transparent layers. It's interesting to experiment and see what colours and **Layer modes** work for you. Have fun exploring the effects of various combinations of Layer modes. After I found what I liked, I left those layers alone, and concentrated on the next step – lighting. I used my photos of carnival glass for guidance in placing my light source, and working out the colour highlights (on another layer, of course).

After much trial and error, I arrived at what
you see on the previous page. I saved my
work, and also duplicated and flattened it,
saving memory for the next stage of the
game. I removed the light-brown background
by using the **Magic Wand**, and cleaning up
my selection with the Lasso tool, just like on
the Skrag project (*see* pages 150–53).

Step 6

For the background, I opted for another
simple colour gradient. I added extra lighting
effects, pulling and pushing my carnival-glass
colours back and forward. Experiment with
colour on its own layer – you can fix or erase
it without damaging the work beneath.

Quick Tip: Find photos of objects lit in the way you want, and use the lighting strategies to refine your own work.

As you can see, 'lighting effects' covers a lot of ground. The golden frame elements were painted using a base colour in Normal mode, then working directly on that layer using both the **Screen** and **Colour Dodge** paint modes. I also took the opportunity to improve my original linework. The segments are much easier to see with white and light-blue lines placed strategically, then muted with my Eraser set at 50% opacity. I then finally used the **Smudge** tool to blur out the interior boundaries of my line layer. In this way, the linework begins to look a part of the overall piece, as opposed to originally looking quite obtrusive and distracting.

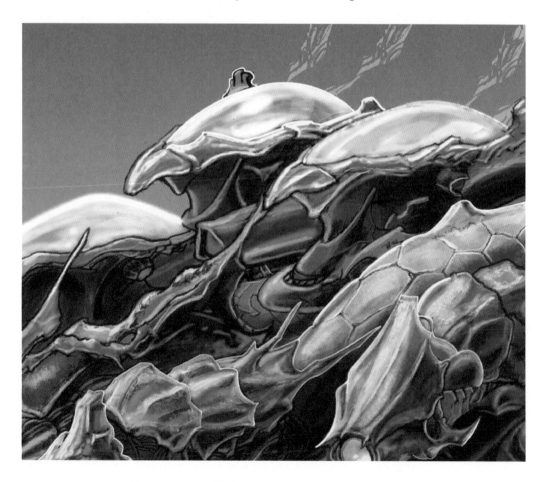

Step 7

When working on the lines for the tail section segments, I saved a lot of time by duplicating my first line pattern using **Layer Copy** (Layer/Duplicate). Not every duplicated line layer fit perfectly, so I scaled the lines using Free Transform (Edit/Transform/Free Transform). For real problem areas, I also employed the **Warp tool** (Edit/Transform/Warp). You can see the interface below – a grid of Bezier points and handles. With the Warp tool, you can bend and twist your object nearly any way you like!

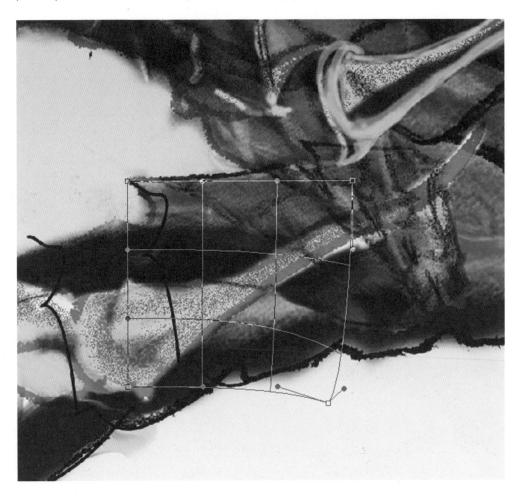

Step 8

I imported the glowing antenna-things, and on a whim switched the layer to **Lighten mode**. Suddenly, the antennae are glowing!

I added this effect to my piece – and learned more about Photoshop. In this picture, you can also see my refinements to the golden pieces of the painting. Happy accidents are fun!

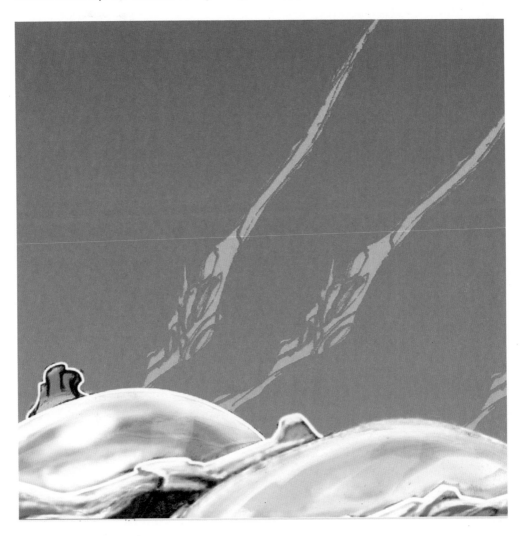

Step 9

Now I'm deep in SFX territory. I want a gentle glow from parts of my machine-beast. This particular flare was made by creating a new document, and choosing **Filter/Render/ Lens Flare**. Immediately the document was flooded with super-black, and a wonderful lens flare.

There are many different types of flare to choose from. Choose what suits your work, adjust the brightness and size of the flare, and hit Enter. Photoshop does the rest.

I saved the flare and imported it, then changed Modes to Screen. **Screen mode** makes all super-black transparent, leaving an isolated effect ready to be tailored to my painting. As you can see I erased the flare at strategic locations, leaving me with ready-made reflective highlights! Next I enhanced all my highlights from the light source with colour grabbed from the flare layer with the Eyedropper tool. Bright spots of reflected light were created by painting in **Screen** and **Colour Dodge** modes. The wan yellow-orange light was from an old texture map I had lying around on my computer.

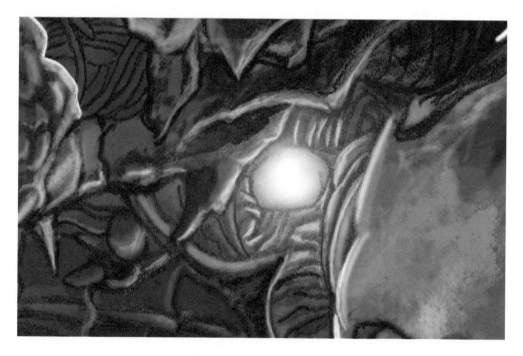

Step 10

For the Eye of Doom, I imagined something organic, yet glowing with menace. I started by making a texture of venous lines, then playing with **Hue**, **Saturation and Lightness** (Ctrl+U). The end result was the purple lines and sickly green glow you see above. I created this as a linear pattern, and then made it circular using Polar Coordinates (Filter/Distort/Polar Coordinates). Using my Airbrush tool with **paint set on Colour Dodge**, I built up the brilliance of the glow until the Eye looked just as I wanted, as if it was charging to fire.

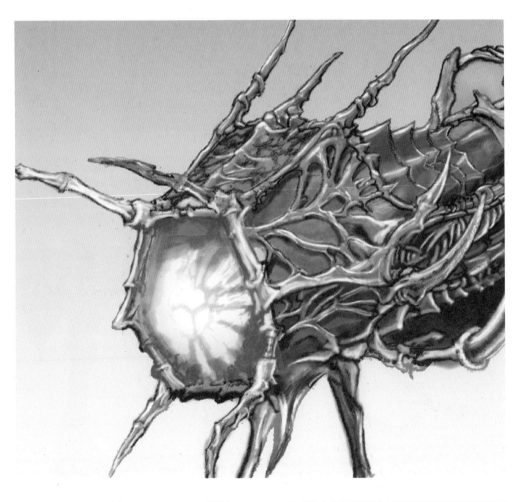

Step 11

At this point, I did some detailed work on
the veiny details of the Eye housing.
Painting with the **Screen** and **Colour
Dodge** paint modes, I quickly pulled out
the veins, giving them the look of organic

metal. Almost done! Now there was only
one thing missing – the glowing auxiliary
braincase at the base of the Basilisk's tail.

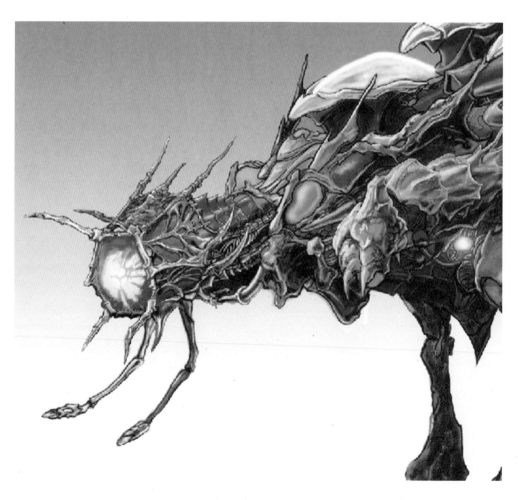

Step 12

For the braincase, I found another neat
texture in my archives, imported it and fit it
into place with the **Warp** tool. The end result,
below, is a sleek, iridescent death-machine
ready to wreak mayhem and destruction!

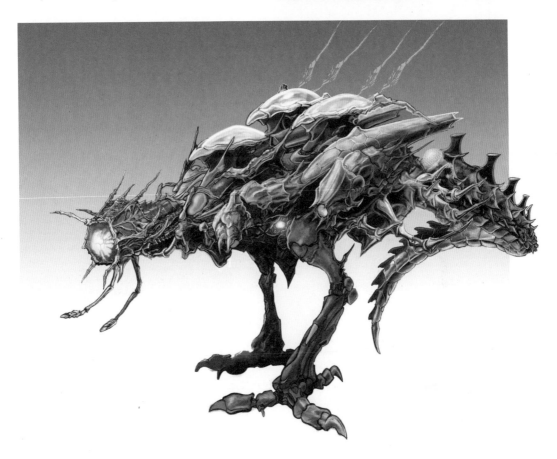

Artist Info: Images © Newton Ewell. Website: www.newtonewell.com

Creating a Credible World

COSTUMES

At first glance we make assumptions about people, not just from their body and movement, but also from their clothing and accessories. Look at pictures from other cultures or from the past and see how dress and equipment tells their story.

WATERCOLOUR FAIRY BY TAVISHA WOLFGARTH-SIMONS

Tavisha works in a very traditional method when painting in watercolours. Her subjects tend to be fantasy-based creatures, fairies, spirits and fanciful costumes. Here is one of her hand-drawn and painted fairy images from start to finish.

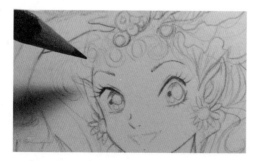

Step 1

Tavisha lays out a very rough sketch in pencil. The smaller image shows her tightening the pencils using a **Verithin Colour Pencil**. The image to the right is her original beginning sketch, which she draws without guides, straight from her imagination.

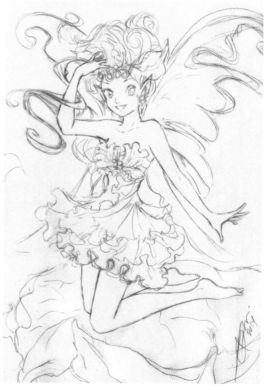

Step 2

Using Verithin Coloured Pencils, Tavisha tightens up the lines, preparing and honing the detail for watercolours. She typically works on 22.9 x 30.5 cm Bristol paper with a Vellum Surface.

She uses various Sable Hair brushes ranging in size from 10/0 to 4.

In the last stage of detailing the image, Tavisha often uses white ink accents, using a **Signo Uniball white pen** and **Titanium White watercolour**.

Quick Tip:

Good quality traditional art materials may be a little more expensive than unbranded ones, but if you buy a reliable brand you will get years of use from it.

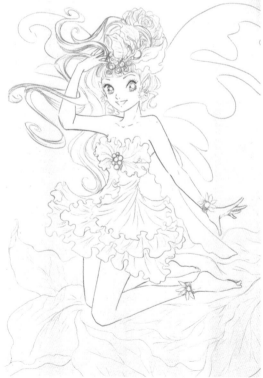

Step 3

The beginning stages of the watercolours are very loose and light and the very lightest colours are applied first. The reason for this is that **colours need to be built up in layers** in order to achieve the finished look. Keep in mind that in watercolour, the less applied the better. You cannot subtract with watercolour, you can only add.

Step 4

Here on the opposite page we have the finished image. Everything here was created very simply by building gradually and carefully with the watercolours. Tavisha has used the same set of cake style Pelikan watercolours that she has owned since the 1980s.

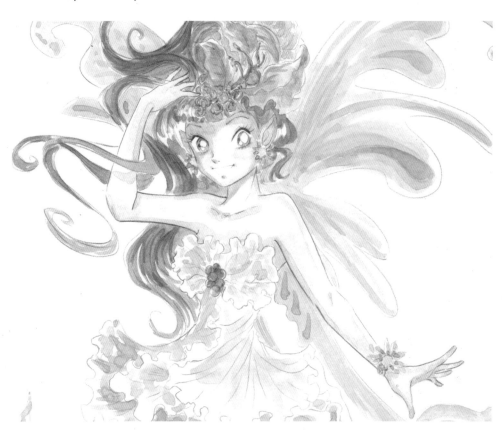

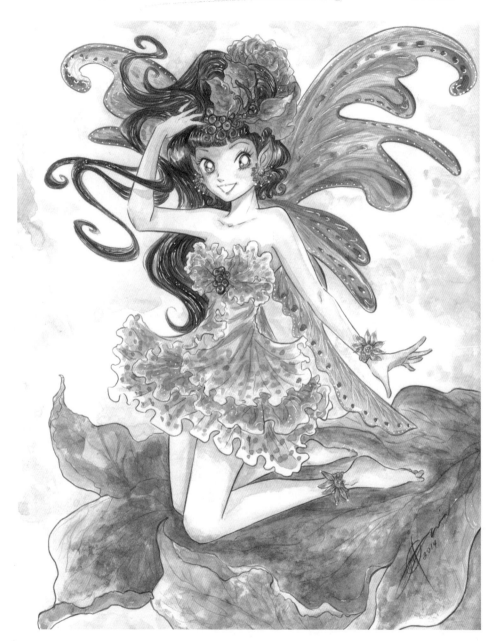

Artist Info: © Tavisha Wolfgarth-Simons. Website: www.tavicat.com

VAMPIRE BOYS BY INKO

Step 1

In this example, the two characters are slightly competitive to each other, but generally friendly. I show this by placing them back-to-back, but give them some eye contact. Generally it is better to place a smaller character in the foreground, so that even if they are overlapping each other, the character behind can still manage to peek out.

Step 2

Now you start adding details: how do they stand, what are they wearing, where are they looking, and any expression on their faces. There are a lot of decisions you must make! Once the rough sketch is done, add individual touches to make the scene more dramatic! The front character's cloak and taller character's long hair are good examples.

Step 3

You can either draw on paper and scan into a computer, or start directly using a digital drawing application. But from this inking stage, everything is processed on a computer using **Clip Studio Paint**. There is a reason the first sketch is drawn in blue pencil. It distinguishes from the black ink you are using to draw on top. Create a new layer and start drawing from the rear character with the G-pen tool. You can see there is extra attention to the textures on materials of clothing and hair.

Step 4

Remember to **create a new layer** before inking another character, and never merge two characters on the same layer, because after finishing the whole process, there is a huge possibility that you, the creator, will want to rearrange them! Thanks to the blue sketching lines, I've been able to get the details of the pose, and the positions of the joints all looking right. The inked drawing looks fine, with well-balanced bodies (no disasters such as one arm longer than the other!), firmly standing on the invisible ground, and glancing at each other.

Step 5

Finally the colouring stage has come. This is **what I call 'Bucket colouring'**, using the Colour Bucket tool to place colours on section to section on a new layer.

The new layer may be on top of the ink layer, but please swap them after colouring, so that the ink line appears clearly, making it easy to distinguish each section's boundaries. Please also colour any hidden part of the rear character (in case you move them around later) and colour sections you want to leave white with a slightly darker colour, for example grey.

Step 6

This is the shading stage. You can make the flat looking drawing more 3D. By giving **shades and highlights**, textures become realistic. Their shirts and the taller boy's stockings are all different shades of white, to give a more interesting flavour. The foreground character's shirt has a light blue touch; the rear character wears a darker shade and cream stockings.

Step 7

Create a new layer on top of all the layers of each character,, and set this new layer as 'Overlay'. Use the **Airbrush tool** to add this image's theme colour: light purple. Wherever you think it is effective, add the colour and you'll see the image is enhanced beautifully.

Step 8

Create a new layer and set it as '100% burn (Outer glow)', and add white highlights on hair, eyes, jewels and anything shiny. **Stack all layers of each character together** into one layer folder, so it's easy to move them together for rearrangement. And it is done!

Quick Tip: Images © Inko. Website: www.Inko-redible.blogspot.com

PETER PAN
BY TAVISHA WOLFGARTH-SIMONS & RIKKI SIMONS

Even classic British characters can be given a somewhat manga spin. This illustration began as a sketch that Tavisha did on a whim, spurred on for no other reason but to create. A reason the Pan himself would probably approve of. Later, when were asked to create a Peter Pan series by an American publisher, we went back to Tavisha's sketch. The project never developed beyond the cover and was never published.

Step 1

Sometimes a first impression is your best. We wanted to preserve Tavisha's original sketch for the cover, so instead of redrawing the image in non-photo blue, we scanned the image into Photoshop and changed it to a pastel blue by using **Photoshop's Colour Overlay** Layer option. The image was then printed out and Tavisha inked it on paper.

Step 2

Once the image was inked using a 0.25 Hi-Tec C Pilot pen and a 0.05 Micron pen, it was scanned into Photoshop at 600 dpi as Millions of Colours. In Photoshop, colour artifacts in the scanned art are desaturated away by selecting Image-Adjustments-Desaturate. Next the lines of characters are made crisp by selecting **Image-Adjustments-Posterize-Levels: 2**.

Step 3

Next we created the logo using an original sketch of half a frame by Tavisha, and some intricate editing by Rikki in Photoshop. The image is set against brown to make the painting feel more natural.

Step 4

The logo frame is painted in both Adobe Photoshop and Corel Painter. Painter has very natural blending tools and Rikki, who started out as a painter specializing in **Acrylic and Oil Pastels**, prefers Painter's blending tools over Photoshop's in this case. The brown outside the frame helps the blending process by smudging into the frame as Rikki blends near the edges.

Step 5

Once painting in Corel Painter is complete, the logo is brought back into Photoshop where it is edited together and a handmade font is added for the title (the font was created in Fontographer by Rikki and Tavisha).

Step 6

The completed logo and frame is saved to a single layer with a transparent exterior. The Pan himself is prepped separately, starting off with flat colours that are built up with highlights and shadows in Photoshop using a combination of Photoshop's **Pencil tool** and **the Paint Can tool** (Anti-alias turned off). We continued, rotating between Painter and Photoshop until the image was ready to fly!

Step 7

The Pan himself is prepped separately, starting off with flat colours that are built up again with highlights and shadows in Photoshop, using a combination of Photoshop's Pencil tool and the **Paint Can tool** (Anti-alias turned off).

Step 8

The finished
cover art.

Artist Info: Images © Tavisha Wolfgarth-Simons & Rikki Simons. Website: www.tavicat.com

PERFECT SETTINGS

It's important to make the look of your world work to support your characters and story. Learn how to set a fantastic and fitting scene for your story.

SAD CIRCUS BY RIKKI SIMONS AND TAVISHA WOLFGARTH-SIMONS

Our comic, *The Trinkkits of the Sad Circus by the Sea*, is meant to feel more like an anime than a manga, but the two art forms share many of the same design elements.

Step 1

Tavisha begins the image by painting a full watercolour scene, which is then **scanned into Photoshop** and adjusted by Rikki with many layers. The ocean is painted digitally, as well as the sky, and the trees in the background are given a deeper blue hue. This adds a sense of magical, dramatic lighting that, though unnatural in the real world, is perfectly suited to a hazy, shimmering fantasy landscape.

Quick Tip: Don't be afraid to try out extreme colour combinations or very intense hues.

Step 2

Tavisha draws the characters and inks them with Microns. They are scanned into Photoshop at 600 dpi, where Rikki then sets down flat colours, using Photoshop's **Pencil tool** and **Paint Bucket**. Hard Anti-aliased lines are used. Their main hues established and the colours are designed to make the characters pop out against the background.

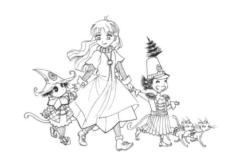

Step 3

Shadows and highlight colours are selected by using the **Eye Dropper tool** to capture a colour and then selecting the darker or lighter colours adjacent to the eye dropped colour. The shadows and highlights are drawn in using the Pencil tool and the Paint Bucket tool.

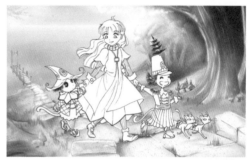

Step 4

This process is repeated over and over until completion.

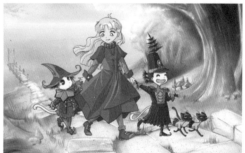

Step 5

Off the Trinkkits go down the path!

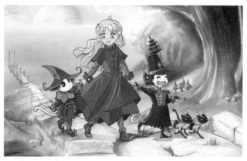

Artist Info: Images © Rikki Simons and Tavisha Wolfgarth-Simons. Website: www.tavicat.com

SHUTTERBOX EPIC VISTA
BY TAVISHA WOLFGARTH-SIMONS & RIKKI SIMONS

In developing fantasy scenes it is important to convey drama, and this is especially true for manga and anime inspired fantasy. We do this by focusing on large theatrical elements. Spaces should be open and wide and lighting should be otherworldly, with **high contrast** between light and shadow. Here is a scene from our fantastical manga, *Shutterbox* and it is a combination of hand drawn and digital design.

Step 1

We begin with the far background. Stars are created by flicking black India ink over white paper (Rikki uses an old toothbrush). The black spatter stars are scanned into Photoshop (PS) and inverted (Menu/Image/Adjustments/Invert). Real clouds are photographed and also brought into PS, then laid over the stars as a **Screen** Layer. In PS we select white as our colour and set the **Gradient tool** to Foreground to Transparent and drag from the bottom of the image to the middle. The image is flattened (Layer/Flatten Image) and saved.

Step 2

Next we combine both hand-drawn and digital elements. Tavisha draws a wispy surreal bridge complete with *mittelEuropan*-style buildings using a .25 Hi-Tec C Pilot pen and a 0.05 Micron pen. This is made into its own layer in PS, cut out and laid over the starry background as a Normal Layer. Lighting on the bridge is painted in

PS to appear as if radiating from below. Rikki then creates foreground buildings using 3D software that can output images as Toon-shaded Line Art. In this case, **Hash Animation Master** is used. These Toon-shaded buildings are imported into PS and painted in PS with far background buildings as lighter than foreground buildings, but both sets of buildings are very dark and dramatic, with lighting from below.

Step 3

Rikki builds two more Toon-shaded 3D buildings in Animation Master and places them as a new layer in the PS image. Tavisha adds hand drawn wires, tiles and little fiddly bits to the surface of the buildings on a separate paper. Accurate placement is ensured by printing out the image and drawing the wires and tiles on a separate paper using a **light table** for assistance. These elements are scanned in and placed as a Multiply Layer over the scene.

Step 4

More white gradient layers are added over the buildings, and again, all light comes from below.

Quick Tip:

A single light source can add drama to an image. Uplighting can be especially effective on both buildings and faces.

Step 5

Finally, Tavisha hand-draws and inks an image of our heroes leaping off into space.

Rikki scans this into PS at 600 dpi as Millions of Colours. In PS, colour artifacts in the scanned art are desaturated away by selecting in PS **Image/Adjustments/Desaturate**).

Next the lines of characters are made crisp by selecting Image/Adjustments/Posterize/ Levels: 2. Characters are toned using a combination of PS, **Pencil tool** and the **Paint Can tool** (Anti-alias turned off). The characters are made into their own layer by selecting Layer/Duplicate Layer. All of the area outside the characters is deleted (use the Magic Wand, Anti-alias turned off,

Contiguous turned on, to select the area outside the characters and push Delete on your keyboard).

The characters are now dragged to our main scene. The image is flattened (Layer/Flatten Image) when finished.

Artist Info: Images © Rikki Simons and Tavisha Wolfgarth-Simons. Website: www.tavicat.com

HAPPY HALLOWE'EN
BY EMMELINE PUI LING DOBSON

Step 1

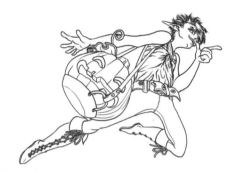

This image shows the digitally inked lines that became the basis for the final composition.

Step 2

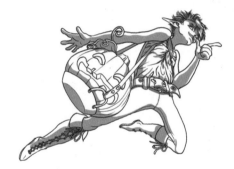

I defined the shaded areas for the character illustration before adding any colours. For this process, as for digital inking, I used a virtual G-pen tool in Manga Studio (aka Clip Studio Paint).

Step 3

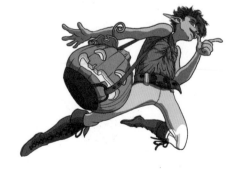

I filled in the flat colours, each on a separate layer. Later, I may merge the layers, as keeping them separate can burden my laptop's memory, making Photoshop slow and sluggish!

Quick Tip: Where you have lots of distracting detail, the background can sometimes be less highly finished.

Step 4

Using a Chalk Texture tool, I built up the background in three layers. The first of these is rendered with colours that vary slightly from the hue of the pumpkin thief's top. I wasn't being strict and using a perspective grid, but it is important to sketch parallel lines attentively.

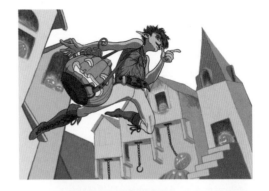

Step 5

Next I drew a middle-distance layer with chimneys and spires, their outlines catching an edge of light, and the final layer comprising the background has a purple sky and a full moon. I knew I could get away with slightly coarse strokes here, because...

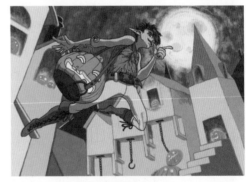

Step 6

...next came adding bats between the background and foreground layers. Here I used a custom brush in Photoshop. I defined a single bat with the tip of the brush, then I experimented with various parameters of the brush to vary the size, angle and scattering of bats.

Artist Info: Images © Emmeline Dobson. Website: ww.emeraldsong.com

Step 7

Photoshop's Brush tool has become smoother in recent years; previously I would prefer to switch to Manga Studio to draw smooth, controlled lines, which is what I've done to outline the words, 'Happy Hallowe'en'.

Step 8

Discipline in keeping different layers separated means that they can be independently adjusted for colour, position, and other tricks like picking out the stroke around 'Happy Hallowe'en' in a golden yellow colour. Clasp your pumpkins tight, trick-or-treaters!

RANKLECHICK
BY TAVISHA WOLFGARTH-SIMONS & RIKKI SIMONS

Years ago we created an illustrated book project called *Ranklechick and His Three-Legged Cat*, a very detailed science fiction comedy that relied on concept design and manga sensibilities to convey a very silly premise. A space-bound Ghoul named Ranklechick and his three-legged cat navigated a very strange, gothic world where ghosts, androids and candy all presented life-threatening problems. We decided that it was best if we used **3D modelling** software along with hand-drawn elements to convey this phantasmagorical place.

Step 1

To start, Rikki built a 3D Model in Hash Animation Master based on Eastern European architecture, output the image as Toon-shaded line art and then distorted the line art using Photoshop's **Spherize Distortion** Filter.

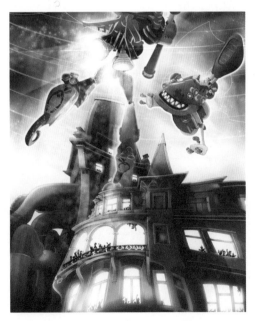

Step 2

Next, in Photoshop, the building was painted with mostly flat colours and a few gradients to get a good feel for the volume of the structure. Purple and green make a great, classic Gothic pop art colour combination.

Step 3

In Hash Animation Master, Rikki next designed, posed and toon-rendered two odd-looking robot combatants. These were also

imported into Photoshop. He rendered them several times, toying with their poses until they finally looked right together.

Step 4

Both of the robots' poses were altered and re-rendered one final time to make them appear more dramatic and placed into the image with the building. They were kept on two separate layers above the canvas of the image in order to move them around a bit more and to make painting the sky and building easier.

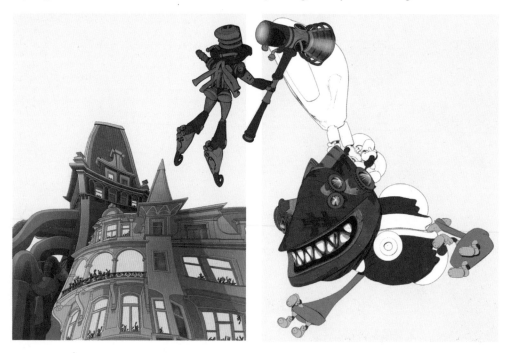

Step 5

In a layer below the building, Rikki paints a space background using various brushes in Adobe Photoshop and Corel Painter.

Quick Tip:
Paint your background on a separate layer and you can also save it for use in other projects or different panels of your comic.

Step 6

The final stage involves a great deal of fussing over painting and adjusting values in Photoshop in order to create mood, volume, and depth.

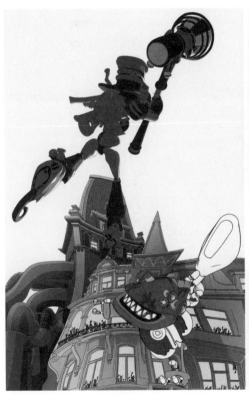

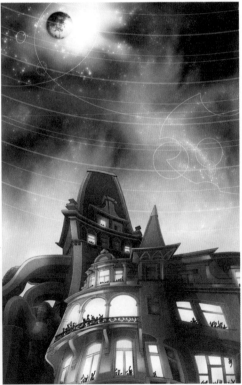

Step 7

The robot models are repositioned in order to appear more energetic and various light and fire effects are painted in Photoshop using feathered masks and the Gradient tool set on Foreground to Transparent.

Step 8

The image is flattened into a single layer when completed and a stage sector of the imagination is set loose on the world.

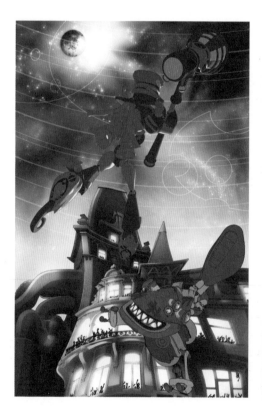

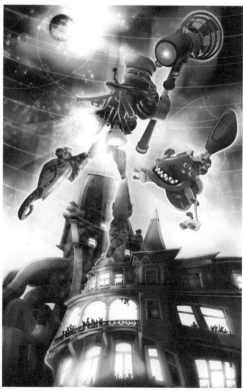

Artist Info: Images © Rikki Simons and Tavisha Wolfgarth-Simons. Website: www.tavicat.com

80s MANGA BEACH BY LAURA WATTON-DAVIES

Step 1

The beach was illustrated using Manga Studio EX 4. The patterns are supplied in this comic creation program so the look of the water was easy to replicate quickly. The beach shade was created using a **Stipple Airbrush** tool. The people walking on the beach were drawn using the Wacom Intuos 4 tablet pen.

Step 2

Once the characters were inked using Manga Studio on separate layers, moving them around to get the most satisfying layout is best. Try out a few different ideas to see if your layout looks good.

Quick Tip: Comic creation programs can help you be more productive by supplying textures and background patterns that would take hours to draw by hand for the same effect.

Step 3

Colour overlays were used on the original Beach background, as well as vectors for clean shapes and palm tree silhouettes. Test out different colour combinations to see how well the colours sit with each other.

Step 4

The male character is not the feature character for this poster, so there is no need to colour him with as much detail as the main girl. Using coloured lines and a colour gradient gives an interesting effect when combined.

Step 5

These are the lines put down for the female character. All sections of artwork were inked **in Manga Studio**. Inking digitally allows for an 'undo' option if you're not comfortable with your initial strokes. Duplicate this layer and lock so it's not coloured in accidentally. This sits on top of the coloured layers underneath your colouring program.

Step 6

This process is called 'flatting', where colour is dropped in each section. Use the **Anti-alias** option if you have used a soft brush when inking your line art, as it will push the colour outward a pixel or two, and not leave white bits in between your colour fill and line art where the soft brush edges sit.

Step 7

Lastly some effects were added to this character by using Blending Options on the base layer. The options chosen here were **Stroke and Drop Shadow**, in colours that match those used in the background scene, to outline the character. A toned pattern with gradient fill was added to the hair to give a hint of Pop Art feeling.

Extra detail to add can include the zigzag section of 'white shine' on the hair strands, dots of white on the character's skin, hair or eyes.

Step 8

On the opposite page is an illustration of the scene put together, with star graphics added around the two character layers. Some elements may need moving around at this stage to make sure nothing overlaps or clashes, but those finishing touches are worthwhile. If you like your poster, save a high resolution jpeg and take it to a local printer, who will make copies for you. You can give the posters out as gifts, use them to promote your comic, or sell them at events to people who like your style.

Artist Info: Images © Laura Watton-Davies. Website: www.PinkAppleJam.com

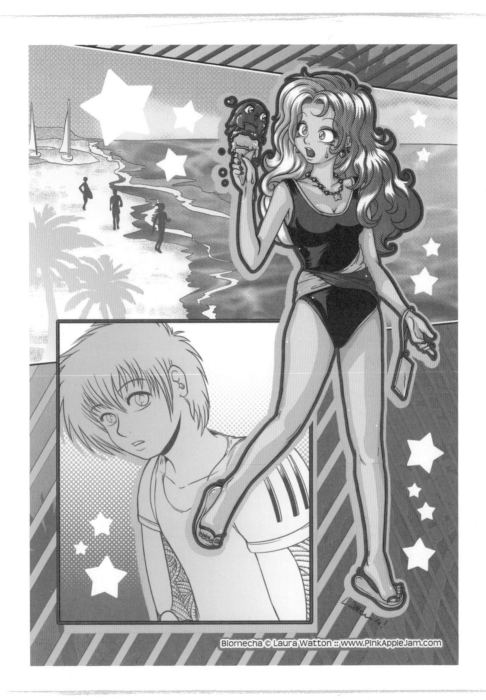

Biomecha © Laura Watton :: www.PinkAppleJam.com

ADDING TEXTURE
BY RIKKI SIMONS AND TAVISHA WOLFGARTH-SIMONS

Step 1

Here you'll see how we add a bit of texture to a flatly coloured scene in our web comic @Tavicat. As always, Tavisha starts the comic out by drawing it in **non-photo blue**. This will make it easier to remove the pencil lines and focus on the inks when the image is scanned into Photoshop.

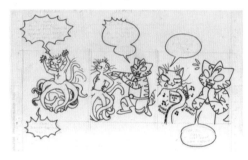

Step 2

The art is scanned into Photoshop (PS) at 600 DPI as Millions of Colours. In PS, colour artifacts in the scanned art are desaturated away by selecting **Image/Adjustments/ Desaturate**). Next the lines of characters are made crisp by selecting Image/Adjustments/ Posterize/Levels: 2. Characters are toned using a combination of PS's Pencil tool and the Paint Can tool (Anti-alias turned off).

Pastel yellow is used as base colour to make the scene feel safe and comical. Look at Pippi be bad! She's a sweet monster!

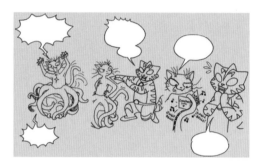

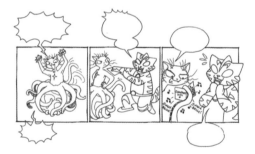

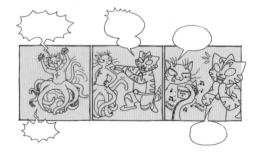

Step 3

We now want a mystical nebulous patch of deep space. Rikki creates the textured sky using several scans of images combined. Real clouds and scanned sheets of Japanese tone are combined in Photoshop and layered under misty gradients and Screen Layers.

Step 4

The textured sky of misty tone is coloured using a pastel dark blue and purple using **Photoshop's Colour Layer** selection in the Layer List. This is done in Photoshop by making an empty layer over the tone layer and filling it with a colour, in this case purple or blue, and then in the Layer List, we change it's state from Normal to Colour. This is then placed over the tone layer.

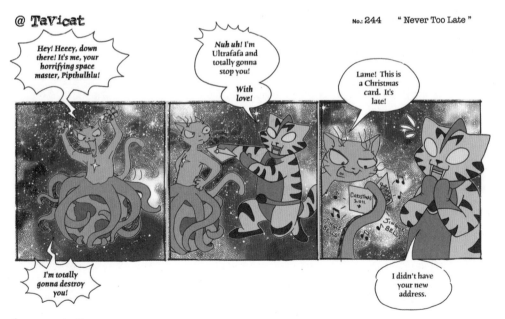

Artist Info: Images © Tavisha Wolfgarth-Simons and Rikki Simons Website: www.tavicat.com

WINSOR&NEWTON INK

...rough
...one is
...shed in FIRE

भूः

one is established in AIR

भुवः

one is established in the SUN

स्वः

the meditation on the

Selling with Manga Style

POSTERS

Manga imagery is used to sell a wide range of products and ideas, from incorporating cute characters in merchandise design, to using manga look-alikes or actual characters in advertising. Study how other artists make enticing images, perfect for posters, flyers and merchandise, and spend time on making your own 'sales pitch' as attractive as possible.

UK theme. I divided the shape into sections and wrote memos of what to draw in each section – because a specific city is the theme, each memorial drawing is placed in order of their geometrical relationship.

MANGA MANDALA POSTER BY INKO

This depicts World War I Memorials in London. First and foremost, the planning stage is so crucially important: it allows you to imagine the final look of the poster.

Step 1

Select the Thick Pencil tool and sketch out compositions of a mandala pattern in Blue on Clip Studio Paint. I chose the Union Jack as the underlying motif in this poster for its

Step 2

I loaded actual photos of motifs already taken from a research trip for this project, and layered them onto the canvas. Start drawing with the **G-pen tool** in Red on new layers. It is always better to separate layers between each section and step, so they will not merge together – then you can rearrange them as you wish later. The reason why I chose Red for the inking is to give a heavenly glow and lightness by avoiding dark outlines. These would appear too strong and busy on this poster because there is so much detail in it.

Step 3

Make those inking layers you have just done invisible, and now start inking the main section in this order: the Cenotaph, a soldier, a nurse, then finally a poppy wreath, all on separate layers. The idea is to draw the background first, then a foreground object, then an object on top of that, so you work through the layers from the background up. It is always a good idea to ink whole figures, even when some parts will be hidden by other figures, to give a natural flowing line to your inking.

Step 4

Duplicate the soldier and the nurse's ink layers and apply the Gaussian Blur Filter on them to tenderly emphasize the outlines of these figures. Then the inking stage is over! Now start colouring with the **Colour Bucket** tool in the same order as you inked: the background memorials, the Cenotaph, the soldier and the nurse, then finally the poppy wreath. Some figures overlap their boundaries for a dramatic effect.

Step 5

On top of each colouring layer, create new layers and set all of them as **Overlay**. Then start adding shading effects. This is not a realistic drawing, so very simple shading is more suitable and gives a look more suited to manga style. Use Bright Yellow Green as a key colour, and highlight on character figures and trees. A hint of pink Airbrush can be added as you wish, to make the overall colour look soft and tasteful.

Step 6

Set the Union Jack layer as Overlay. Set its opacity to 11% and place it under all layers. Then create a new layer underneath it and fill the whole layer with Light Blue colour using the Colour Bucket tool. Create another new Overlay layer on top of it and start adding clouds with the Cloud Gauze tool. Keep carefully checking the balance with other elements.

Step 7

Create a new layer between core section layers and all other layers beneath, and set it as Screen. Then colour White Yellow with the Airbrush to give a **glow** around the core section figures. This avoids the centre part of the image blending too much into the background. Finally, add texts in Black with setting the layer as Overlay. ...and it is done!

Artist Info: Images © Inko. Website: www.Inko-redible.blogspot.com

SEA BREAM DREAM BY LAURA WATTON-DAVIES

This is a rework of a comic that I drew for a magazine competition a few years ago. It can be fun to draw your old characters in a slightly newer style, because the inevitable improvement becomes obvious, and it can be quite difficult to see for some artists. I republished the comic in a small landscape-format booklet, and wanted to make a large poster to promote it.

Step 1

This is the sketch. It is A4 in size. I was quite lazy and took a **photograph** of it via **smartphone**, emailed it to myself and then set it up in my digital inking program, completely bypassing the scanning section of the process altogether. As a rough stage this is perfectly fine.

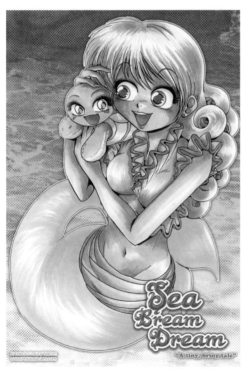

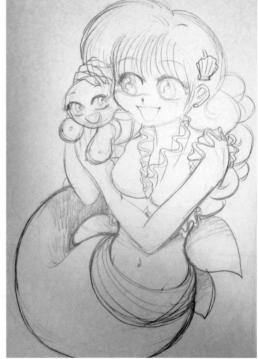

Step 2

These are the inks. The hair strands in the character's fringe took quite a while, as there were a lot of them. To get them set up just right, I drew on a separate layer, and erased elements of line art behind the strands, as it is easier to tidy up inks, using this method.

Step 3

The inks were printed onto a regular piece of printer paper using a laserjet printer. Starting with the lightest colours first, colour was added to the line art. The colours reflect a pastel and sweet theme with underwater colours such as seaweed greens, coral pinks and oranges.

Step 4

The background was created using tones from the digital inking program exported in black and white, into another digital paint program that converted the patterns into colour. Using colour overlay options, a white to blue gradient was selected for the background; the sea pattern was placed in on top of that background and opacity reduced, as the middle layer; finally, the white dot gradient pattern was placed on top as the finishing layer.

Step 5

The background and the character image are placed together, with a bit of tidying up, and borders used around the character to lift them off the background. The title is added in the bottom-right corner and sent to the printers to have posters printed of the design.

Artist Info: Images © Laura Watton-Davies. Website: www.PinkAppleJam.com

ELF BY SONIA LEONG

Creating a digital black and white inked piece requires a good graphics tablet or tablet computer that lets you use a stylus pen in place of a mouse or touchpad, and image editing software such as **PaintTool SAI**. Here is a portrait with many potential uses – print, poster, flyer, merchandise and more.

Step 1

Start off with a very rough sketch. I often use a pale, but bright colour. This makes the inking process easier by providing good contrast.

Step 2

It's very important to add a new layer on top before beginning to ink, so you can keep your black lines separate for maximum editing capabilities. Start inking. Try to stick to one or two brush sizes at the most, and **link pressure sensitivity to size**. This makes your resulting lines look much more organic and similar to traditional work with real pen and paper. A key tip is not to zoom in too much, or you'll get bogged down in too much detail that won't be noticeable from the whole picture.

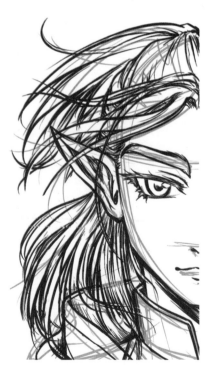

Step 3

Remove the sketch lines and start cleaning up your inks. Digital inking has some advantages – you can nudge parts of your image to correct sizing and placement. Furthermore, it's easy to add white or remove lines already drawn, so you can make overlapping strands of hair and highlights really stand out.

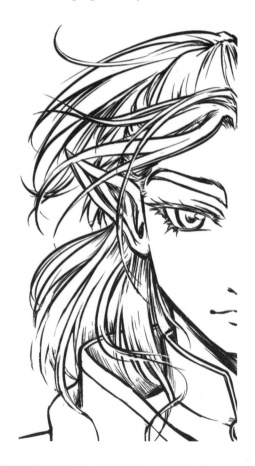

Step 4

Add any textures and shading using traditional techniques, such as **hatching** or cross-hatching, if you want to give your artwork an organic feel. In this example, the angles of the hatched lines on the jacket match the contours of the character's body.

Step 5

The finished picture has strands of silver flames drawn over the top, like they are dissipating from a spell the character has just cast. They mirror the colour of his irises, for extra visual impact.

Artist Info: Images © Sonia Leong. Website: www.fyredrake.com

COVERS & TITLE PAGES

A cover that grabs attention will boost your chances of success. And splash pages are important in comics – even in black and white manga. They add an extra dimension to the world you create by allowing your reader to see your characters in colour.

RHUMBAGHOST BY RIKKI SIMONS

Here is the title design for Rikki's new *Rhumbaghost* web comic series. Rikki's style is a rough combination of American concept design and *c.* 1920s newspaper comics, whimsical manga cartooning and the peaceful simplicity of Finnish children's books. He begins all of his personal work with hand-drawn illustrations and either finishes them with real or digital painting, or a combination of the two.

Step 1

Rikki begins the logo for *Rhumbaghost* by drawing measured lines lightly with a mechanical pencil. Each letter of the logo is given the same amount of space, except for the first letter, which is twice as wide. When satisfied with the design, which is drawn on **bristol board with mechanical pencil**, Rikki inks the logo with a black .3 Copic Multiliner.

Step 2

Next, the pencils for the logo are erased with either a kneaded or white eraser. The character of Rhumbaghost is then drawn by Rikki in Mechanical pencil and inked with a **0.1 Multiliner**. Rhumbaghost has a nice boat.

Step 3

Two separate images are created next. These will be background layers to be added when the image is painted in Photoshop. The starry image is **white acrylic** flicked with a toothbrush across black paper, and the swirling impasto clouds are inked by hand with a **black Copic BM Multiliner brush pen**.

Step 4

The next steps are all about process, building up from flat colours in Photoshop and **blending in Corel Painter**, and switching back and forth between the two programs until the image feels right.

Step 5

To the right is a screenshot of Rikki's layer list in Photoshop. As you can see, there are many layers. Most of these are tiny incremental changes in tone and colour and impasto strokes that alone seem very insignificant, but together with one interacting with the next and the next, they make up a digital painting that is completely altered if even one layer is removed.

Step 6

In the end we are left with the finished image of Rhumbaghost marooned in his nice rowboat. A whimsical, moody scene of fairy lights and the cold quiet murmur of night. Poor little Rhumbaghost.

Artist Info: Images © Rikki Simons. Website: www.tavicat.com

THE MEDITATION ON THE SACRED UTTERANCES BY EMMELINE PUI LING DOBSON

This is the beginning of the title page of a four-page comic. As the title 'The Meditation on the Sacred Utterances' was very long, I wanted to do an ambitious treatment of the lettering.

Step 1

For guidelines, I drew an ellipse with perspective-adjusted lines ruled out from its centre.

Step 2

Also, I set out to handcraft the pages, to make each one an attractive object itself. I realized I had a problem: laying down black ink for the background (in order to write white letters on top of it) was wiping out my pencil guides.

Step 3

By watering down the black ink a little, I was able to still see my pencilling. I started to letter the page using **Windsor & Newton white ink** loaded into a dip pen with a G-pen nib.

Step 4

The final hand-drawn page is intricate, yet quite rough in many ways. I anticipated that there would be many refinements that would be easier to do in the digital environment. I scanned the page in to start working on it digitally.

Step 5

The cleaned-up page is 99% pure black and pure white. Using the **Hue/Saturation** functions in Photoshop, I changed all the reds to whites without affecting the other hues. Patiently, I refined the letters and pictures with the virtual G-pen brush tool in **Manga Studio**.

Step 6

As an aside, another lettering challenge on page three of this comic was to incorporate some Sanskrit script into the artwork.

I had only one chance with each glyph to get it right, so I practised using a special calligraphy nib I bought for the job. Tools pictured here, anti-clockwise from top-left: coloured pencil, **straight-edged nib** and **G-pen nib** attached to nib holders, digital camera able to shoot in RAW format, soft brush for laying down large areas of black, fine brush, mechanical pencil, Windsor & Newton India ink, pipette, Deleter No.2 white ink, Windsor & Newton white ink.

Step 7

To help me, my co-author sent me files of the glyphs required. I also researched calligraphic approaches to Sanskrit online.

Step 8

Here is the final, digitally-enhanced title page. I applied the shading in Manga Studio using a Coloured Pencil tool. I think it was worth the effort to have not four, but eight final pages – the physical pages and their digital siblings.

Artist Info: Images © Emmeline Pui Ling Dobson. Website: www.emeraldsong.com

ROSIE & JACINDA DEMON CLOUD BY INKO

Here is artwork for the cover of Richy K. Chandler's manga, character designs by Zarina Liew. The manga author made a sketch of his ideas for the cover to help me make the art. I used **Clip Studio Paint** to create the exact composition of the image.

Quick Tip:

When preparing your work for printing, always check the details of the final trimmed size and proportions and make sure your art will fit those.

Step 1

The right half is the front cover with two main characters: one feminine girl, one tomboy girl, standing back to back. The left half is the back cover, leaving some space between characters for text to be placed later. The frame line at the edge is the limit of the cover image; anything beyond the line will be trimmed off by the printer and finisher. So any art that's crucial to the cover must be kept **inside if the border**.

Step 2

I had fun throwing in details and adding effects to show the characters' hair, skirt, and tie blowing in the wind. I picked **Thick Pencil tool** to start inking on a new layer, referring to Zarina Liew's original designs. The inking colour is hazel brown to soften the impression. It is clear that the viewer or 'camera' is looking up at the two characters so the image has a hint of perspective.

Step 3

Fill colours section by section with the Colour Bucket tool. Use the **Cloud Gauze tool** to draw textured cloud; and the Airbrush tool for the magical effects around the wand. Please do not forget to create new layers and use them for each stage. That way you can go crazy of the cloud on the background yet it will have no effect on the characters you've drawn.

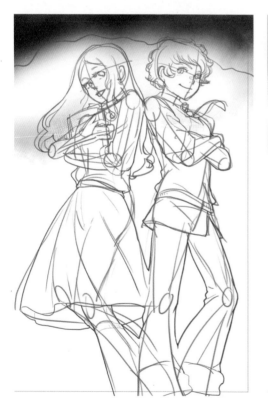

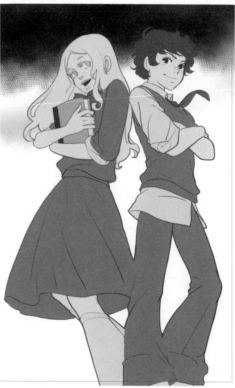

Step 4

Carefully apply shading effects on new layers using slightly lighter and darker colours to give a three-dimensional look. You can see there is extra attention on drawing the strands of hair. The skin colour is allowed to go over the edges of the hairlines with the **Airbrush tool** to give the characters a healthy glow.

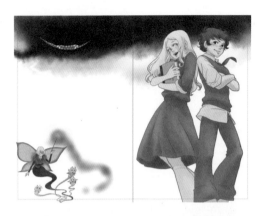

Step 5

Duplicate the ink layer and use the Gaussian Blur filter on it, which makes the ink line stronger but lets it blend into the image nicely. Create a new layer and set it as **Overlay**, then add pink and lime green colours wherever you want to enhance the image.

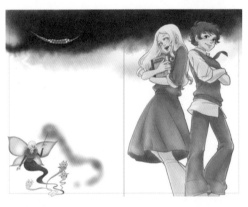

Step 6

The blue division line is still kept visible to see the balance of the whole image. Now let's add the vanilla background colour. Drop shadows make the figures look like cut-out paper puppets in front of a stage curtain. To keep the whole image dreamy and warm, avoid using black or very dark colours for shadows.

Step 7

Create a new layer and set as 100% Add
(Outer Glow). Start adding the evil eyes of the
demon cloud in Yellow Green, the magical
glow of the wand, the gleam of the
characters' eyes, cheeks, lips, hair, and edges
of clothing with White. If you want to add
an extra shine, use the Airbrush tool to draw
over the glow-effect areas.

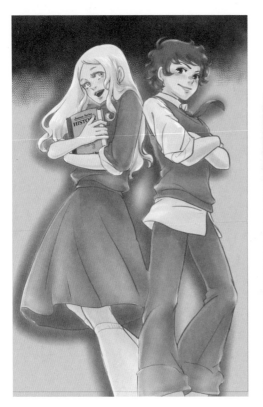

Step 8

Create a new layer and set it as Screen, then
use the Gradation tool to apply Copper
colour in a translucent gradation from the
top of the cover to half way down the
image. In the same way, apply **Translucent
to White gradation** from halfway down to
the bottom of the image. This makes the
colours more delicate and tasteful from the
top to the middle, then they fade into white
light at the bottom. This gives a beautiful
atmosphere to the whole piece. Pass this
image to the letterer for the final stage.

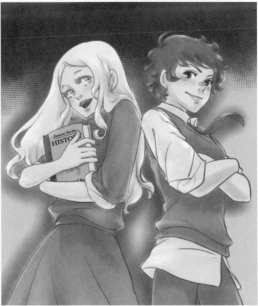

Step 9

Finally the cover is done, with all the text in place. The title looks effective on top of the drawing. Readers can see different characters on the front and back covers, but still perceive the same continuous theme with unifying colour on both sides. The whole process and every single stage help to create colourful and fun effects on the cover!

Artist Info: Images © Inko. Website: www.Inko-redible.blogspot.com

COVER IN COLOUR BY BRUCE LEWIS

I prefer monochrome manga, but learning to work in colour is important. After all, covers, frontmatter, and other special pages are usually done in full colour, or at least in wash tones, so you'll need to know how.

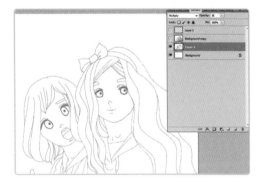

Step 1

For this colour cover I am going to use the image of the two girls from Chapter One (*see* pages 125–28) and colour it in, in Adobe Photoshop. I first scan it in (at 600 dpi, greyscale), open a copy of it, duplicate the pencils into a separate Pencils Layer, blank the Background Layer to white by deleting, then dial down the **opacity in the Pencils to about 30%**. I then create a separate Colour Layer on top of it all, switch to RGB mode, and Save As.

Step 2

I create a custom brush using the Brush palette in order to get the effect I like – in this case a sort of crumbly, wet-edge watercolour look. Turner I'm not, but for this project I want a soft pastel, *josei* manga feel, and this brush fits the bill better than a hard-edged brush would. ('Sloppy' colouring also makes it easier to hide one's mistakes – a skill vital for any pro artist.) I lock the Background and Pencils Layers and begin laying down base colour in the Colour Layer. To keep things in order I create a new layer for each 'colour group' (greens, blues, etc.) as I go along. All your Colour Layers should be set to **Multiply** into the Pencils Layer below.

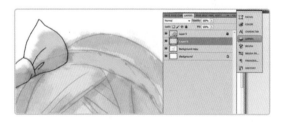

Quick Tip:

Experiment with different brushes in your graphics program to find the ones that suit your style best. Try making your own custom brushes!

Step 3

Colouring proceeds layer by layer until both figures are done. You'll note I added an opaque Highlights Layer for the sparkles in the girls' eyes. **Adjust the Colour Layers** as desired until you get the opacity, saturation, lightness, and texture you want, then flatten them all into a single Colour Layer, leaving the Pencils Layer unflattened on top of the Background. At this point you may wish to pop a new Inks/Embellishment Layer on top of the pencils as digitally 'ink' the drawing; adjust the Brush, Filters, and other controls to get just the right line quality. I like a sketchy line these days, so that's how I 'inked' it.

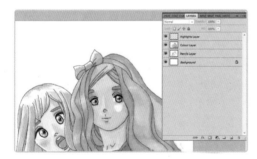

Step 4

Background and format time! Since this drawing is to be the cover of an actual, printed manga (a doujinshi, in this case),

I need to reformat the image to bleed size and portrait orientation. This done, I create a new Background Layer on top, set the **opacity to about 50%**, and drop in the royalty-free public-domain image of Autumn leaves I downloaded from Morguefile (www.morguefile.com). Finally, I use the Erase tool to delete the portions of the foliage that overlapped the girl's head.

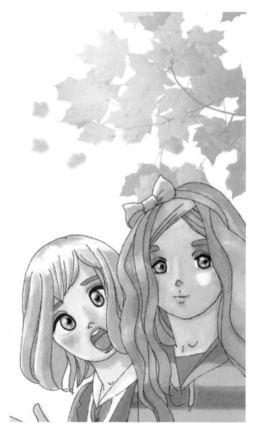

Step 5

I'm trying to evoke an autumnal feel – what the poet Keats called 'season of mists and mellow fruitfulness'. I want the image to be suffused with a mellow, fruity colour. Unfortunately, my first try looks a bit more like the colour of, well, urine. I drop in a Gradient Blend (gold to white) in the Background Layer, and then **adjust the saturation and opacity** until I get something more like falling leaves. Almost done!

Step 6

It's not a cover without a title, so I create a Type Layer here and type in the name of the book and the author (trying different fonts, colours, and effects along the way to find the look that matches the mood). I then check and configure the colour (switching to CMYK Mode for digital press), change the document to its final size and resolution, and Save As a PDF file.

Step 7

So, on the **next page** is the colour cover!

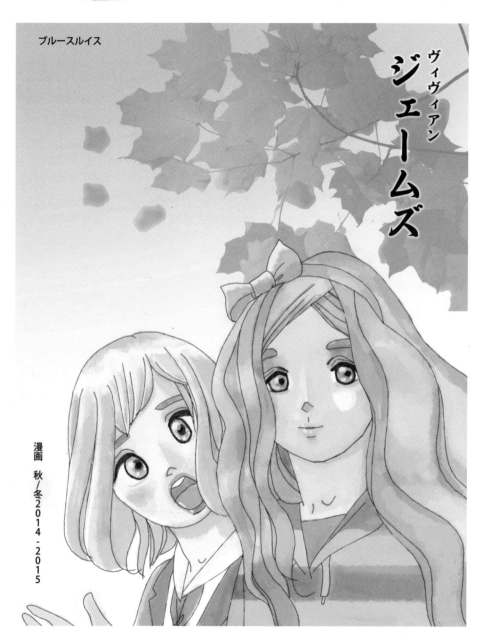

ブルースルイス

ヴィヴィアン

ジェームズ

漫画　秋/冬2014 - 2015

Artist Info: Images © Bruce Lewis. Website: www.brucelewis.com

BAD EGG COVER BY DAN BYRON

Step 1

After thinking of the initial idea for *Bad Egg*'s front cover I drew the artwork that would be needed, the characters and the logo. I **scanned** them and got to work using my old copy of Photoshop 7.

Step 2

Next I coloured the areas I wanted to erase. There may be easier techniques to do this sort of thing, but my limited skills are self-taught. Do what works for you.

Step 3

I used the **Background Eraser tool** to erase all the areas I had coloured...

Quick Tip:
Using a bright colour for areas you want to erase helps to ensure you don't miss anything.

Step 4

...then I used the Polygonal Lasso tool to separate the two groups of characters in my original image.

Step 5

I moved both sets of characters over to the logo as separate layers.

Step 6

Next I opened the photographic elements of the Image. I take all the pictures myself, around the town I live in.

Step 7

I used the Polygonal Lasso tool again to cut out the row of houses, then duplicated and flipped the layer.

Step 8

Next I thought I'd add a dramatic skyline behind the houses.

Step 9

After a little bit of tweaking, all the images fit together nicely.

Step 10

At this point I thought the flattened greyscale image looked a bit too plain and dull, so I decided to add another element - fire!

Step 11

Again I coloured the area I wanted to replace and used the background eraser to remove it.

Step 12

The fire looked good, so I just flattened it and put it into greyscale.

Step 13

The completed cover! (*See* opposite page).

Artist Info: Images © Dan Byron. Website: www.facebook.com/badeggcomic

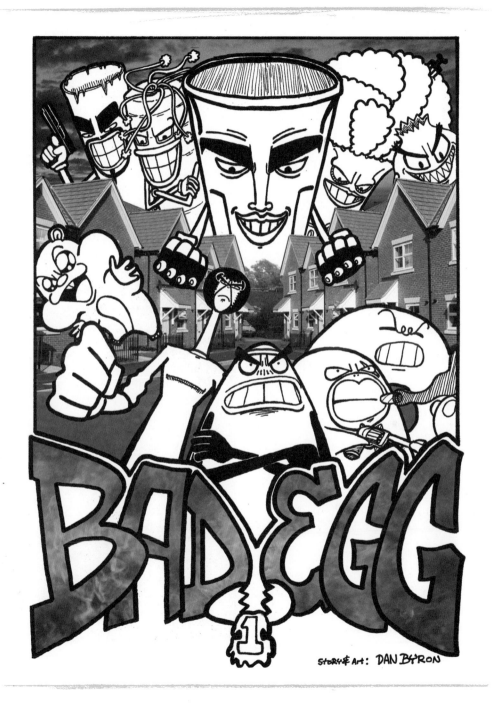

MINAMICON COVER
BY EMMELINE PUI LING DOBSON

Step 1

I made these sketches to explore what would be the best pose and facial expression.

Step 2

I inked this image digitally using my tablet-laptop, Wacom stylus and Manga Studio (now alternatively called Clip Studio Paint).

Step 3

My preferred colouring process is to keep flat colours separate from modification layers that add shadows and highlights.

Quick Tip:
If you don't have a large-format printer or scanner, your local print shop can help.

Step 4

To add shadows using watercolour, I took my line art on a USB stick, and an A3 piece of cartridge paper, to a local printer. I used aquarelle pencil on this page, and scanned this result in to a new layer of my master Photoshop composition.

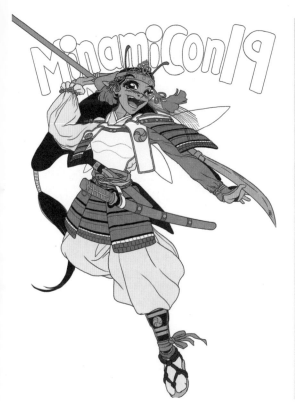

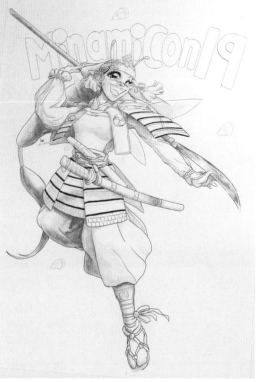

Step 5

I found some textures online for cloth and background, taking care to source stock where the creator has permitted free reuse. Layer masks hide parts of the texture, so you only see the part that's 'coloured inside the lines'.

Step 6

To finish off, I added richness, highlights and reflections on the crown, the blade, and other details, using Photoshop brushes.

Step 7

A public domain image of a Japanese screen painting of the Battle of Sekigahara makes an appropriate background. I applied a halftone effect to it to create a more graphic image.

Quick Tip:
If you use elements sourced from books or the web, make sure the images are in the public domain.

Step 8

The final image comprises text elements as well as the focal character; these were designed into the composition right from the thumbnail stage, so all elements appear in balance together.

Artist Info: Images © Emmeline Pui Ling Dobson. Website: www.emeraldsong.com

SHUTTERBOX
BY RIKKI SIMONS AND TAVISHA WOLFGARTH-SIMONS

Step 1

With our comic *Shutterbox*, a story about a school for muses in the afterlife, drama is best conveyed with theatrical underlighting and cool colours that convey a sense of a capricious daydream.

Rikki starts the image off by painting a nebula-rich starscape in **Corel Painter**. He uses oil pastel brushes in Painter and blends them together with various blending tools. The colours are saturated and accentuated in

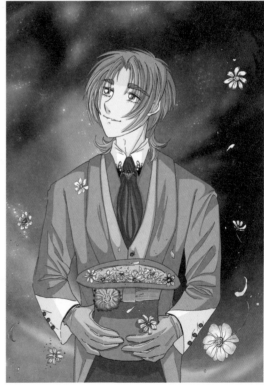

Photoshop by duplicating the main nebula layer and stacking and alternating Screen Layers and Overlay Layers, and deleting sections where necessary using the Eraser tool in Photoshop.

Step 2

Tavisha then draws our main character, Thomas, using a non-photo blue mechanical pencil and then inking with Micron pens. The image is scanned into Photoshop at 600 dpi and then cut out using the Magic Wand tool and lifted to its own layer. Rikki colours Thomas using Photoshop's Pencil tool and Paint Bucket tool. The shadow colours are chosen to reveal the highest possible contrast while still remaining printable. **Printable colours** are chosen from Photoshop's colour picker in the Colour Libraries and chosen from Pantone Solid Coated Colours.

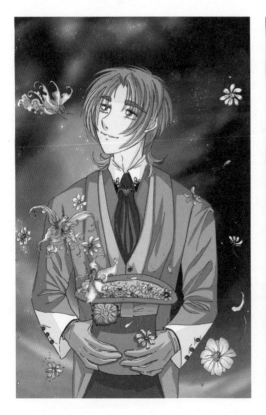
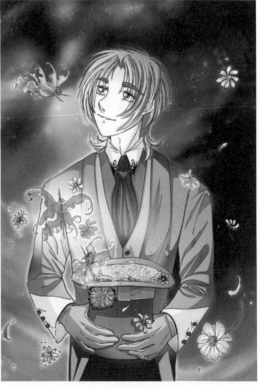

Step 3

Tavisha then draws fairies separately from Thomas, which are also scanned at 600 dpi and brought into the image in Photoshop. The fairies are reduced in opacity, then duplicated, with the duplicates changed to Overlay Layers to increase saturation. Glows are added to the fairies by selecting one of the normal semi-opaque layers and selecting Layer/Layer Style/**Outer Glow**.

Step 4

Lighting contrast and saturation are all increased and a film texture is added as an overlay layer.

Step 5

Now the logo is created using separate drawn elements which are edited together to create a pleasing frame.

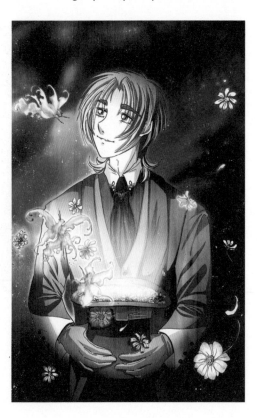

Step 6

Thomas is partially edited over the logo. When this is pasted down, Thomas will match perfectly with his other image on the layer below.

Step 7

The finished cover art. It just needs the creators' names and other text details for use as a cover, but it would also work as a poster just like this.

Quick Tip:

If you design and draw your own frames and graphic elements, it makes your project even more an expression of your own ideas.

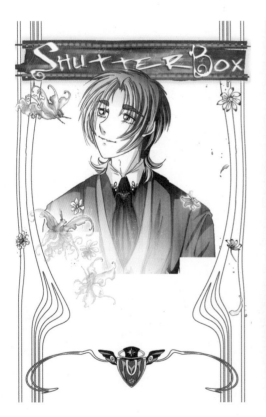

Artist Info: Images © Rikki Simons and Tavisha Wolfgarth-Simons. Website: www.tavicat.com

MEET THE TEAM

Get to know the artists and writers who made this book, and find out where you can see more of their work. They come from all over the world, from a wide range of backgrounds, some self-taught and some with formal art education. Some make their work entirely in the computer, others use some traditional techniques; most mix their media to achieve the best effect. Their energy and enthusiasm for making manga is the common thread that unites them all.

HELEN McCARTHY
(GENERAL EDITOR)

When Helen McCarthy first encountered Japanese popular culture in 1981, there was no book on anime in English – so she decided to write one. She kickstarted the anime fandom in the UK in 1990, and she founded the groundbreaking anime magazine *Anime UK* in 1991with publisher Peter Goll, artist Wil Overton and artist/writer Steve Kyte. She edited the magazine until it folded in 1996.

She has written 11 non-fiction books on anime and manga, as well as contributing chapters and essays to many academic publications, and writing for magazines and online.

Helen is a popular speaker in universities, colleges, libraries and art institutes in the USA, Europe and Japan. She also curates film seasons and leads workshops on comic-making, costume, needle art and writing. Her work has won several awards including a Japan Festival Award for her work in promoting Japanese culture, and a Harvey Award for her book *God of Manga: The Art of Osamu Tezuka*.

Websites
www.helenmccarthy.wordpress.com
@tweetheart4711

DAN BYRON

Since as long as he can remember, Dan Byron has spent most of his free time drawing. Cartoons and comics have always enthralled him and he's been a huge fan of manga for about 20 years. Most of Dan's favourite manga

series fall into the *shonen* or *seinen* genres. He loves the crazy character designs, the wildly varied art styles, the creative page layouts, the comedy, the drama, the super destructive battles, the strong sense of morality and justice, and the constant cliffhanger endings.

In *Bad Egg* (entirely created by Dan: the script, the art, the layouts, the photography and the editing), Dan wanted to incorporate the elements he admired from all global art styles into something that could really be called a British manga. He decided to have no human characters, to open up the possibilities of what the medium can do. However, the story has a serious tone in part, so to keep the reader grounded in reality he uses photography of his own London suburb for the backgrounds, giving the story a true urban street edge (and incidentally linking back to Tony Luke's innovative work for Japanese publisher Kodansha in the 1990s).

Websites
www.facebook.com/badeggcomic
www.twitter.com/badeggcomic

SUMMER CRUZ

Summer Cruz was born in California and raised in Texas. With family on all sides that practised art in some form, the creative roots run deep for Summer. She likes to take inspiration from animals and mythical beasts, since they offer more canvas and possibilities to her. Amongst her essential kit she lists a computer and graphics tablet for hardware, and Manga Studio 5 as her chosen piece of software.

In her free time she plays action/adventure games and drinks copious amounts of soda. Summer currently resides in Michigan, USA, with her boyfriend and their cat.

Websites
www.Mizumew.Deviantart.com
www.purrcipitation.tumblr.com

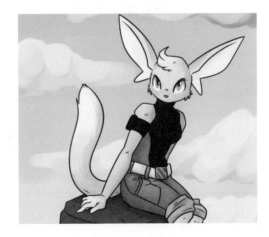

NEWTON EWELL

Newton Ewell was born in 1962 in St. Louis, Missouri, USA. He's always wanted to be a starship engineer. From childhood, he has been obsessed with science fiction hardware. His love affair with mecha began when he was just three years old, thanks to a man named Gerry Anderson. Meanwhile, Newton was also getting into Japanese SF anime with shows like *Prince Planet* and *Astro Boy*, as well as becoming a fan of Japanese live-action special effects shows such as *The Space Giants*.

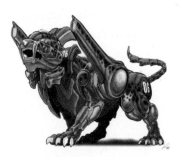

Newton taught himself how to draw and paint so that he could make the pictures he loved. The result has been a career as an illustrator, conceptual and production designer, and mechanical design contributor to a number of role-playing game publications. This experience helped Newton get work on videogames. He's at home with both traditional and digital artwork, from pencils to 3D animation. He's looking forward to working with games companies on many future projects in the fantasy, SF and horror genres.

Amongst his essential software kit, he lists Adobe Photoshop, Adobe Illustrator, Maya, 3D Studio MAX, Corel Painter and De-Babelizer Pro.

Website
www.newtonewell.com

INKO

Inko is a Brighton-based Japanese freelance manga artist, actively producing manga cartoons, illustrations, and picture books. Her artwork is heavily influenced by both Japanese traditional art and Japanese pop art. To this traditional foundation she adds her original style, which often has a feeling of darkness and a mystique all of its own.

She teaches how to draw, and has given talks about manga for both children and adults at schools, museums, galleries and libraries all over the UK, including the British Museum and the Victoria and Albert Museum. She is also active in many art projects including short film animations and comic strip posters for Art On

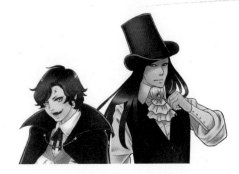

The Underground. Inko's manga can be found in *Manga Quake*, *War*, *Howl!*, *Tempo-Lush Tales* and more comic anthologies. Her first illustration book *Uniform Girls* will be published in May 2015, and she has plans for many more projects in the future.

Websites

www.Inko-redible.blogspot.com
www.facebook.com/inkoMangaManger/

CHIE KUTSUWADA

Chie Kutsuwada was born and brought up in Japan. She moved to England to further her studies, graduating from the printmaking department of the Royal College of Art, London. She is now based in Brighton, working as a professional manga artist. Chie's work is deeply influenced by the *shojo* and *yaoi* genres but she enjoys drawing many other genres, from samurai fighting to horror.

She creates the stories of her manga, as well as doing the illustrations, as in her first published *King of a Miniature Garden* (included in *The Mammoth Book of Best New Manga 2*, Constable & Robinson, 2007) and *Moonlight* (collected in *The Mammoth Book of Best New Manga 3*, Constable & Robinson, 2008.) Chie also works with other writers, and her books are available in most English speaking countries and in Japan. She is also collaborating with Inko on an ongoing web comic project, an anthropomorphism of London Tube stations: *Go! Go! Metro!*

Besides creating manga, Chie also attends many manga-related events in and out of the UK. She runs manga workshops at schools, libraries, and museums including the British Library and Victoria and Albert Museum.

Website

www.chitan-garden.blogspot.com

SONIA LEONG

Sonia Leong is an illustrator specialising in manga, living in the UK. Her *Manga Shakespeare: Romeo and Juliet* is well-loved around the world. She first rose to fame as a winner in Tokyopop's first UK Rising Stars of Manga competition (2005/06) and Winner in *NEO Magazine*'s 2005 Manga Competition. Most recently she created a comic for Toyota about a superhero who uses her Aygo car to fight a giant monster.

Sonia is the Company Secretary of Sweatdrop Studios, a leading UK comic collaborative and independent publisher of Manga. She is currently working on her two webcomics, *FujoFujo!* (about female geeks/otakus) and *Manga Mama* (a semi-autobiographical strip about motherhood), an illustrated fantasy novel *A Brush With Magic*, and volume two of the romantic comedy *Love Stuffing*.

Amongst her essential drawing materials she lists Sakura Micron, Staedtler and Kuretake ZIG Mangaka fineliners, Muji and Pentel brush pens and Faber-Castell Polychromos colour pencils; for hardware, a Canon CanoScan 9000F scanner and Wacom Cintiq Companion tablet; and for software, Adobe Photoshop CS5, Adobe Illustrator CS5 and PaintTool SAI.

Website
www.fyredrake.net

BRUCE LEWIS

Bruce Lewis is an illustrator, writer, graphic designer, and vocal performer. One of the first American comic artists to work professionally in the manga idiom, Lewis has produced hundreds of pages of 'American manga' since 1993, including titles such as *Robotech, Star Blazers, Gall Force*, and many more.

He is also the author of *Draw Manga: How To Draw Manga In Your Own Unique Style* (Collins & Brown, 2005), a best-selling how-to book based upon his two decades of

teaching extremely popular manga drawing workshops. The book has also been translated into Chinese to help the millions of manga fans in China to create their own comic art.

In addition, he has spent many years working professionally in the advertising and entertainment industries as an art director, advertising artist, and designer. When not drawing or writing, Bruce also works as a professional vocal performer in the broadcasting, voice-over, and anime dubbing industries. He lives in Tarrant County, Texas, USA. His essential kit of drawing materials includes tracing paper, photocopier paper (for roughs), thin card, pens and pencils and sticky tape.

Website
www.brucelewis.com

EMMELINE PUI LING DOBSON

Emmeline has been drawing ever since she was little, first imitating the pictures in Fighting Fantasy gamebooks, then creating her own monsters, robots and brave adventurers to explore mysterious worlds. The 1990s introduced her to Japanese visual culture through videogames and anime, and in that era she started making and self-publishing comics. By 2009, she had worked in the UK videogames industry for a decade. She loves making manga-style images because they are full of an indescribable energy that excited her as a teenager.

The multiverse of comics from Japan is breathtakingly diverse, yet she also reads and learns from an international range of comics traditions, and has a deep respect for the skills of the expert draftsperson. As long as she can

create great artwork and tell stories that have depth, convey heartfelt meaning, and entertain, she is not discouraged by those who criticise manga. She feels this is a wonderful era when learning resources for any software or technique are at our fingertips. She has stories she passionately wants to communicate from her heart to the hearts of her audience.

Website
www.emeraldsong.com

TONY LUKE

Tony Luke has been a professional artist for over 25 years. His big break came in 1993 when Kodansha published his *Dominator* serial in their anthology monthly *Comic Afternoon* alongside *Gunsmith Cats* and *Oh! My Goddess*. *Dominator* first appeared in black and white in music magazine *Metal Hammer* in 1988 before exploding into Japan in full colour. Tony was the first Briton to have a self-created comic series published in a Japanese anthology.

He followed this up with animation work on the TV pilot *Archangel Thunderbird*, and, in 2003, an animated adaptation of *Dominator*. Tony has worked with some of the biggest names in comics and animation in Britain and Japan. He now freelances on a variety of projects and commissions.

His advice to young artists: Don't be held back by invisible 'manga rules' – just experiment and try different things out until you find your own, unique, voice. Amongst his essential hardware kit he lists the Apple iMac and Wacom Cintiq Touch tablet; and for software, Photoshop and Poser Pro.

Website
www.tonyluke.deviantart.com

RIKKI SIMONS AND TAVISHA WOLFGARTH-SIMONS

Rikki Simons is a voice actor, writer, and artist. He is most famous for being the voice of the robot in a dog suit, GIR from *Invader ZIM*. As a writer he is known for the science fiction and fantasy novel *Hitherto a Lion*. Rikki is also a background painter in animation, most noted for his colour design on *Invader ZIM*.

Tavisha Wolfgarth-Simons is a German and Japanese American artist who produces her art and stories under the studio name of Tavicat (and sometimes, WiredPsyche). During her two decades of publishing manga-influenced comics in the American market, Tavisha's comics and illustrations have been published by Nickelodeon, Tokyopop, Digital Manga, and SLG Publishing, among many others.

Rikki and Tavisha are married. Original illustrated books and comics that they have created together include *Super Information Hijinks: Reality Check!*, *Ranklechick and His Three Legged Cat*, *ShutterBox*, and now *The Trinkkits*.

They live near Pasadena, California with their cat, Pippi. They met at Disneyland in 1990 and were married on Halloween 1994. They are both Kentucky Colonels. The comics and books Rikki creates with Tavisha can be read and purchased at www.tavicat.com.

Website
www.tavicat.com

LAURA WATTON-DAVIES

PinkAppleJam is the online name Laura uses for her various illustration & personal work projects, a selection of which are featured in this book. She hopes readers will enjoy them and be inspired to draw their own characters too. Working remotely from her studio in Cambridge,

England, she has worked on comics, games, flyers and numerous other art projects for years.

Laura was part of British anime and manga fandom from the early 1990s and is one of the founders of British manga collective Sweatdrop Studios. The culture of making comic arts is very important to Laura. She's been a fan of Japanese comics and animation for over twenty years, and created her own influenced works for just about as long. She has produced a number of comic works, including stories featured in Sweatdrop Studios' anthologies and was also one of the winners of the *Neo Magazine* manga competition in 2006. In 2008 she was a runner-up in the 3rd Rising Stars of Manga United Kingdom and Ireland competition.

Laura continues to publish *Biomecha*, an ongoing manga style comic. *Biomecha* was shortlisted for the 2007 Eagle Awards, and it will be concluded in three books.

Websites
www.PinkAppleJam.com
www.BiomechaComic.com

FURTHER READING & USEFUL WEBSITES

MANGA HISTORY

Koyama-Richard, Brigitte, *One Thousand Years of Manga*, Flammarion-Pere Castor, 2014

McCarthy, Helen, *A Brief History Of Manga*, Ilex Press, 2014

Schodt, Frederik L., *Dreamland Japan: Writings on Modern Manga*, Stone Bridge Press, 1996/2011

Schodt, Frederik L., *Manga! Manga! The World of Japanese Comics*, Kodansha, 1983

www.kyotomm.jp/english/
Kyoto International Manga Museum – the English version of a major Japanese manga museum's website.

www.koyagi.com/index.html
A website packed with information, resources, advice to librarians, teachers and parents, and travel tips for manga fans visiting Japan.

manga.about.com/od/historyofmanga/
A Brief History of Manga and Japanese Comicbooks – a general introduction by various authors.

www.matt-thorn.com/mangagaku/ history.html
An excellent website from one of the leading scholars in the field, Matt Thorn, with especially good insights into shojo manga.

MANGA DRAWING

Antram, David, *How to Draw Manga*, Book House, 2010

Estudio, Joso, *The Monster Book of Manga*, Collins, 2006

Hart, Christopher, *Manga for the Beginner*, Watson-Guptill, 2008

Hogarth, Burne, *Dynamic Figure Drawing*, Watson-Guptill, 1970

Hogarth, Burne, *Drawing The Head*, Watson-Guptill, 1965

McCloud, Scott, *Making Comics*, William Morrow, 2006

Thompson, Keith, *50 Robots to Draw and Paint*, Barron's Educational Series, 2006

Comickers Magazine, *Comickers Art: Tools & Techniques for Drawing Amazing Manga*, Harper Design, 2008

Leong, Sonia, *Draw Manga: Complete Skills* (Video Book Guides) Search Press, 2013

Leong, Sonia and Scott-Baron, Hayden, *101 Top Tips from Professional Manga Artists*, Barron's Educational Series, 2013

Lewis, Bruce, *Draw Manga: Creating Manga In Your Own Unique Style*, Collins & Brown, 2005

www.howtodrawmanga.com
Full of tutorials and advice on drawing manga.

www.morguefile.com
An archive of royalty-free images for artists and designers.

www.sweatdrop.com
Sweatdrop Studios – the website and shop window of the UK's leading manga art collective.

www.tcj.com
An information-packed website for anyone interested in comics as an art form, with contributions from leading scholars, critics, writers and artists.

GREAT MANGA READS
(A small selection)

Arakawa, Hiromu, *Fullmetal Alchemist*, VIZ Media

CLAMP, *Cardcaptor Sakura*, Dark Horse

Hino, Matsuri, *Vampire Knight*, Shojo Beat/ VIZ Media

Kishimoto, Masashi, *Naruto*, Shonen Jump/ VIZ Media

Kubo, Tite, *Bleach*, Shonen Jump/VIZ Media

Miyazaki, Hayao, *Nausicaä of the Valley of the Wind*, VIZ Media

Oda, Eiichiro, *One Piece*, Shonen Jump/VIZ
Ohba, Tsugumi and Obata, Takeshi, *Death Note*, Shonen Jump Advanced/VIZ Media

Otomo, Katsuhiro, *Akira*, Kodansha America

Samura, Hiroaki, *Blade of the Immortal*, Dark Horse

Takaya, Natsuki, *Fruits Basket*, TokyoPop

Tanabe, Yellow, *Kekkaishi*, Shonen Sunday/ VIZ Media

Tezuka, Osamu, *Astro Boy*, Dark Horse

Toboso, Yana, *Black Butler*, Yen Press

Toriyama, Akira, *Dragon Ball*, VIZ Big/ VIZ Media

Urasawa, Naoki, *Pluto*, VIZ Media

MANGA-BASED ANIME
(A small selection)

Akira (movie), 1988
Astro Boy (movie), 2009
Bleach (TV), 2004–12
Code Geass: Lelouch of the Rebellion (TV), 2006–07
Death Note (movie), 2006
Dragon Ball Z (TV), 1996–2003
Fullmetal Alchemist (TV), 2003–04
Ghost in the Shell (movie), 1995
Inuyasha (TV), 2005–05
Neon Genesis Evangelion (TV), 1995–96
One Piece: The Movie (movie), 2000
Yu-Gi-Oh! (TV), 1998–2006

INDEX

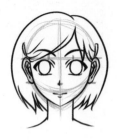

Artists' websites

Dan Byron: www.facebook.com/badeggcomic
Summer Cruz: www.purrcipitation.tumblr.com
Emmeline Pui Ling Dobson: www.emeraldsong.com
Newton Ewell: www.newtonewell.com
Inko: www.Inko-redible.blogspot.com
Chie Kutsuwada: www.chitan-garden.blogspot.com
Sonia Leong: www.fyredrake.net
Bruce Lewis: www.brucelewis.com
Tony Luke: www.tonyluke.deviantart.com
Rikki Simons: www.tavicat.com
Laura Watton-Davies: www.PinkAppleJam.com
Tavisha Wolfgarth-Simons: www.tavicat.com

FLAME TREE
PUBLISHING

Creators of fine, illustrated books,
ebooks & art calendars

www.flametreepublishing.com
blog.flametreepublishing.com